The wildlife photographs of
# Laurie Campbell

First published in Great Britain in 1987 by
Colin Baxter Photography Ltd.,
Unit 2/3, Block 6,
Caldwellside Industrial Estate,
LANARK, ML11 6SR.

First published in paperback in1990 by
Colin Baxter Photography Ltd.

**British Library Cataloguing in Publication Data**

Campbell, Laurie
    The wildlife photographs of Laurie Campbell
    1. Scottish photographs. Special subjects: Nature
    I. Title
    779.309411

    ISBN 0-948661-13-5

Design by Charlie Miller Graphics, Edinburgh

Printed in Great Britain by
Frank Peters Printers Ltd., Kendal, Cumbria

The wildlife photographs of
# Laurie Campbell

COLIN BAXTER PHOTOGRAPHY LTD., LANARK

**Acknowledgments**
The author would like to thank the following for their assistance:
The Nature Conservancy Council
Rothiemurchus Estate
Gary and Brian Douglas, Tiptoe Farm

**Biographical note**
Laurie Campbell was born in 1958. On leaving his home town of Berwick-upon-Tweed
he worked for two years as a keeper in Edinburgh Zoo. He studied photography in Edinburgh
from 1977-81, and now works as a freelance wildlife photographer. He travels widely
throughout Scotland in search of his material, and his work has been published previously in
books, magazines, and as postcards. He lives in Edinburgh.

**Red Grouse**

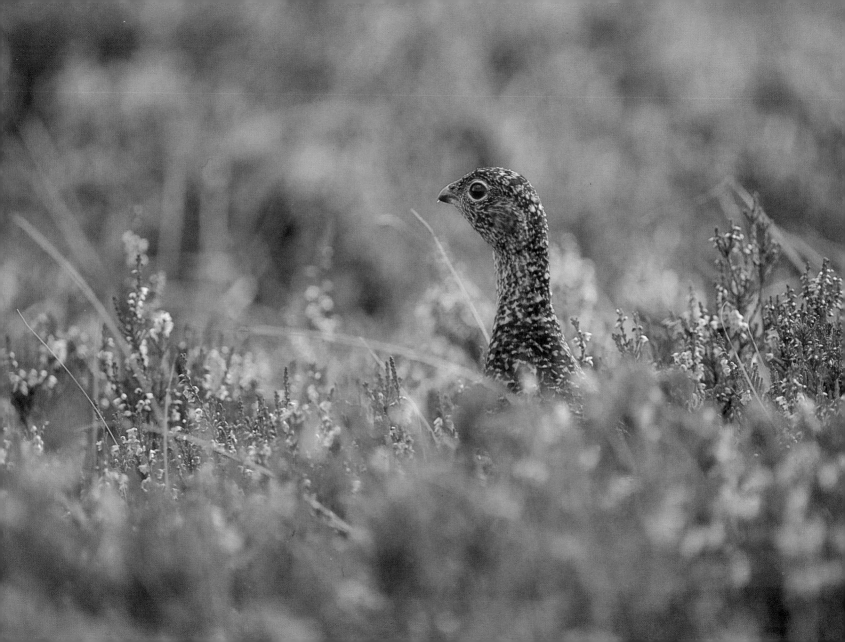

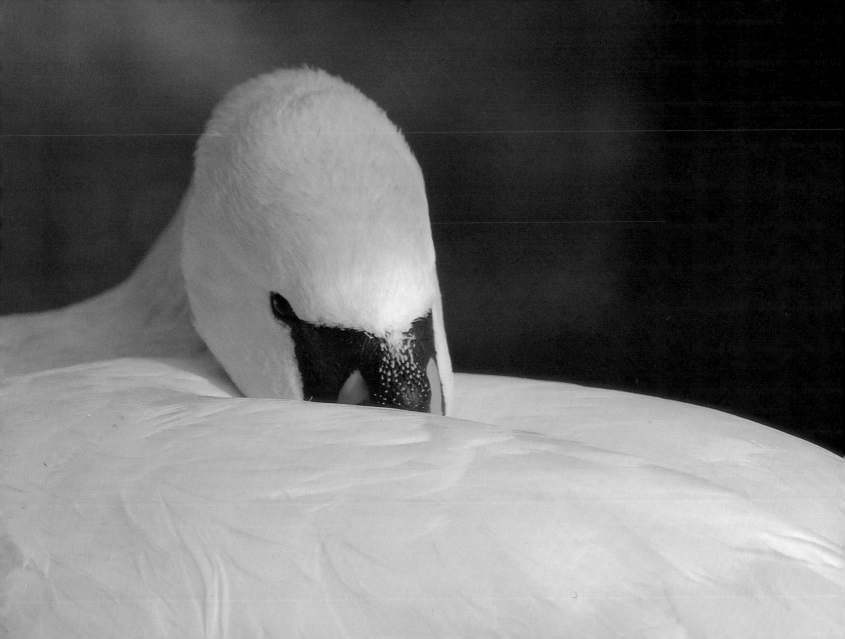

# Contents

Mute Swan

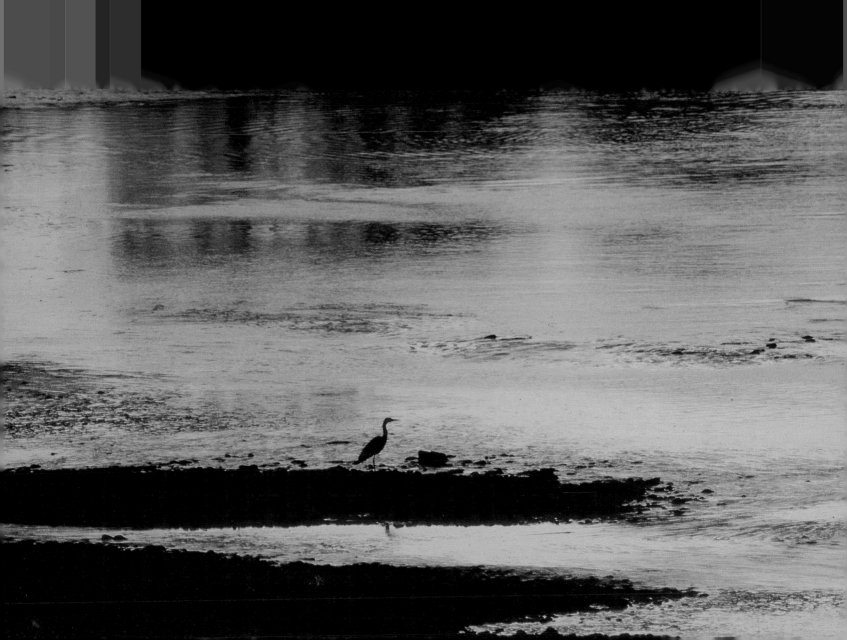

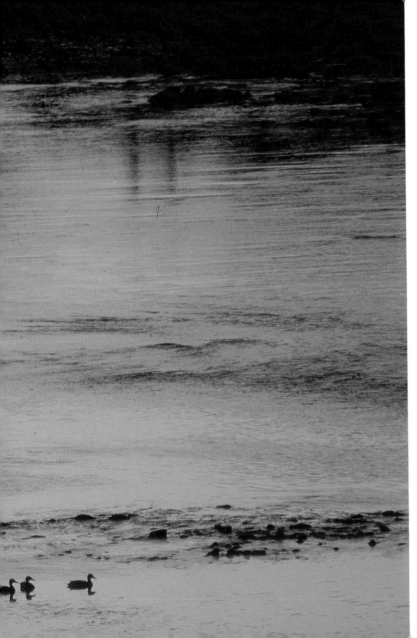

**River Whiteadder**

# Off the beaten track

For as long as I can remember I have had a deep love of nature and the countryside. From my early teens onwards I would set out to explore the area around my home town of Berwick-upon-Tweed, and I realise on reflection how fortunate I was to find myself in the midst of so many different types of wildlife habitats – coastline, estuary, arable farmland, woodland, and moor. Over the years I visited and revisited certain places until I knew precisely where and when I could expect to see a particular species.

I went on these early expeditions alone, and always on foot, and I would derive immense satisfaction when, as sometimes happened, I witnessed unusual or special events in nature. Later I would try to describe these experiences but I was always left with a feeling of frustration because I found it hard to convey exactly what I had seen, and why it was so special. Once, for example, in the very early morning I saw some fox cubs playing and sunning themselves in a local park. The scene made a strong impression on me, and I can still remember it vividly, but I found it difficult at the time to share my excitement with anyone else.

When I left school I moved to Edinburgh to work as a keeper at the Zoological Gardens, and it was about this time that I developed an interest in photography. Two years later I began studying photography at college in Edinburgh, but I had already realised that this was the medium I had been searching for in order to share my experience with others. Equipped with camera and telephoto lens, and using the knowledge I had already accumulated, I began to revisit my old haunts. At first my progress was slow. My main problem was getting close enough to my subjects and I began to understand why so many wildlife photographers work from hides. I started improvising my own hides from ready-made materials, such as driftwood on beaches, and my photographs improved. However, to this day I prefer to go out 'hunting' with my camera, to stalk animals and birds rather than working within the confines and limitations of a hide. Stalking can often produce more interesting results, because the subjects are shown just as they appear in the field, and without any contrivance. It is a more exciting way of working too, and, at times, less hazardous than being in a hide. I was once visited by the police after being mistaken, by two public-spirited old ladies, for a camper about to be washed

9

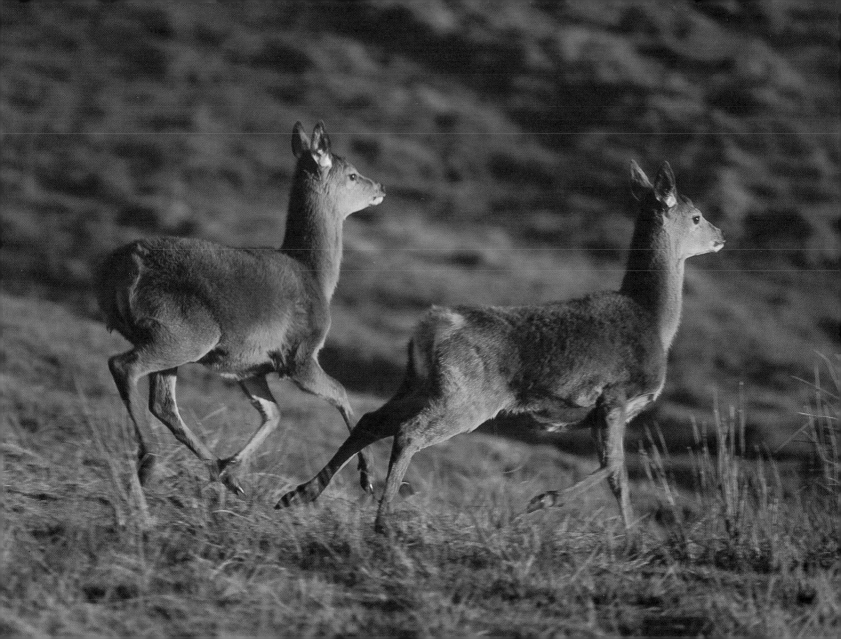

away by the tide; and I have had the somewhat unnerving experience of finding a hide in which I was sitting being gradually demolished by a herd of cattle!

In some ways my present method of working is very similar to my early expeditions around Berwick, although on a larger scale. I still believe that familiarity with particular locations is of great importance to a wildlife photographer, and I return again and again to selected areas throughout Scotland. Mull, the West Coast, Speyside, and Deeside are among my favourite 'hunting grounds' and with each visit I learn more about the seemingly inexhaustible variety of wildlife to be found in these regions. As a whole, Scotland, with its vast areas of unspoilt land and rich diversity of habitats, must be one of the most challenging and rewarding places in which to work. Some native species, the wild-cat and the pine-marten for example, have never really been properly photographed in the wild.

The older style of wildlife photography tended to concentrate on producing an accurate image of the subject, usually in a rather conventional setting. Most bird photographs were taken at the nest and with the use of artificial lighting, for example. Nowadays, thanks to improvements in photographic equipment and a demand for more unusual and 'natural' pictures, it is possible to be more ambitious. The changing of the seasons and weather conditions alone provide the photographer with a wide range of backdrops against which to work. Many of my own best photographs have come as a result of maximising the effect of these factors, and when I am photographing 'static' objects, such as trees or grasses, the right conditions are essential. I often judge that something would look better at a different time and make a mental note to return later, when I will have a chance of getting a better-than-average picture.

Experience has taught me that it is important to develop a 'photographic eye' for wildlife photography. At first I would go out single-mindedly in pursuit of a particular subject, paying little attention to the wealth of material that I passed on the way. I have come to realise that everything in nature is worthy of attention, if only we can see it. Raindrops on grasses, the sun filtering through autumn leaves, tracks in the snow; these are all things which at first seem insignificant but which can be every bit as rewarding as more spectacular subject matter.

Persistence, rather than patience, is another key factor in wildlife photography.

It is not enough to be prepared to wait for hours on end in the hope that something will happen. You must know what you are looking for and that you are in the right place at the right time to find it. If it is necessary to buy up the entire stock of hazelnuts from three supermarkets and then spend several months baiting an area in order to get a good photograph of a red squirrel, then that is what you must do.

My aims are simple: to show subjects at ease in their natural environments and, by doing so, to increase people's awareness of the countryside. If, through my photographs, I can encourage them to share my belief that this is something worth preserving, and if I can also convey some of the excitement and wonder I myself have experienced, then I am satisfied.

Laurie Campbell
Edinburgh

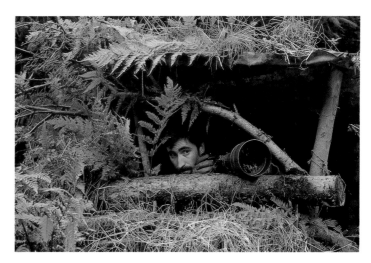

**Laurie at work in hide**

# Herons by moonlight

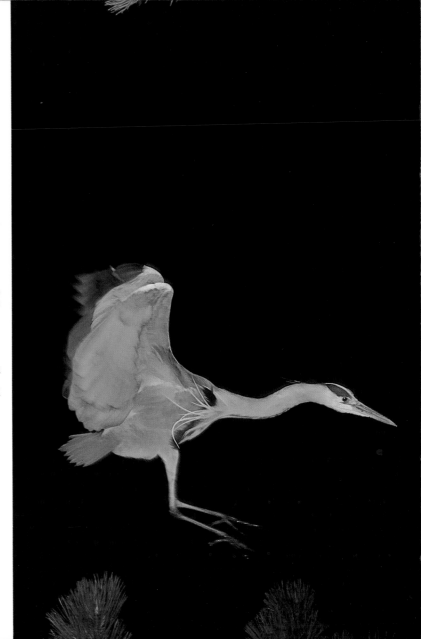

It was a cold winter's night as I walked home along the river bank. I had been unsuccessful in my attempts to catch badgers on their nocturnal wanderings and suspected that, with the temperature well below zero, they would continue to lie low for some time. Many of the smaller streams and marshes were frozen hard, bringing countless water birds onto the tidal mudflats and saltmarshes of the river estuary. Now the tide was at its highest and only the sound of a grey seal surfacing with a snort, then breathing heavily before diving again, broke the stillness which had fallen over the river.

My feet crunched on the frosted grass as I neared a group of Scots Pines which stood at the top of a low, ivy-covered bank. Suddenly four herons broke cover from the top of the tall trees, flying high over the river and calling in alarm as they went. Recovering my composure I remembered that I had often noticed splashes of 'whitewash' over the path at this spot. I had presumed these to be the droppings of cormorants, but now it seemed obvious that the trees were in fact a high-tide, night roost for herons. At low-tide, large areas of the mudflats, dotted with streams and pools, would be exposed – an ideal feeding ground for these birds. I decided to return the following night, hopefully before the herons arrived.

Two hours before high-tide I had settled myself at the base of a particularly broad Scots Pine. I wore dark clothing, with several extra layers underneath, and prepared for a long, cold, wait. Nearby the ivy leaves glittered with frost in the light of a full moon. Ice which had formed on the pools cracked and groaned eerily up and down the riverside as the incoming tide slowly began to flood the mudflats.

Over an hour had passed when I felt a faint prodding below my right elbow. The sensation continued for a few seconds, then began to move up my arm. I kept quite still. When it reached my shoulder I turned my head very slowly and found myself face to face with an equally surprised woodmouse. Horrified by its mistake it leapt straight into my lap before escaping into the ivy. At precisely that moment I heard the beating of wings above. I looked up and saw a heron alighting in the tree. It made the usual croaking noises which faded to an intermittent purr, then it walked along the branch, wings outstretched as if on a tightrope, before settling on one leg and falling asleep. Over the next two hours another five birds flew in to join the roost.

Several years later, and after many failed attempts, I managed to devise a way of photographing these birds at night. I nailed a plank of wood close to the trunk of the main roosting tree, about thirty-five feet above the ground, and positioned myself on it with camera and flash-units. From here I could photograph the birds arriving from most directions, and I discovered that, if I sat very still, they would fly in to within about fifteen feet before spotting me and veering off. Windy nights proved useless because I relied completely on the sound of approaching wingbeats as a signal to raise the camera ready for firing. From that point I had to work very quickly in order to find the bird in the viewfinder and take the picture – the whole event rarely lasting more than five seconds. The necessity to work with the tides and in calm weather meant that suitable nights were few and far between. This meant, however, that the birds were always surprised by my visits – unlike the numerous salmon poachers, foxes, and roe deer that passed below, oblivious to my presence.

River Tweed
February

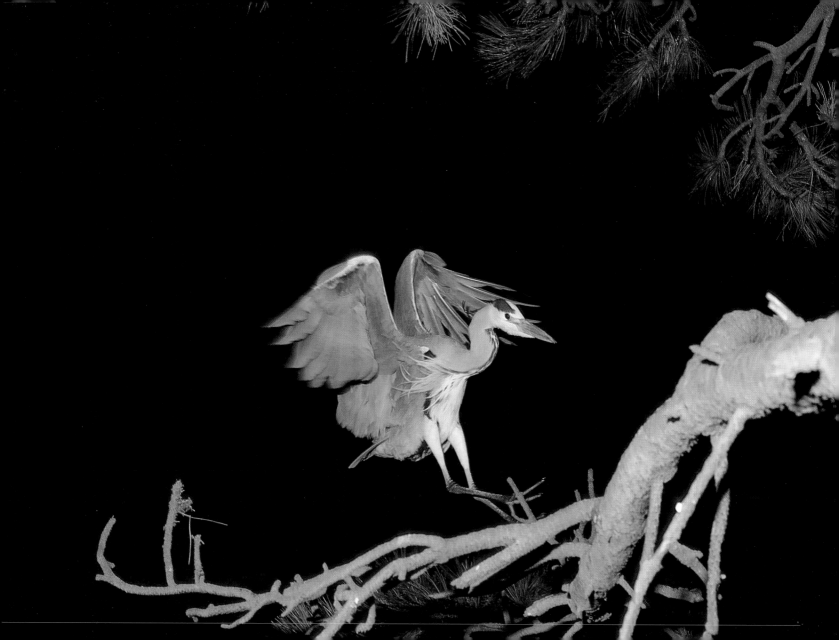

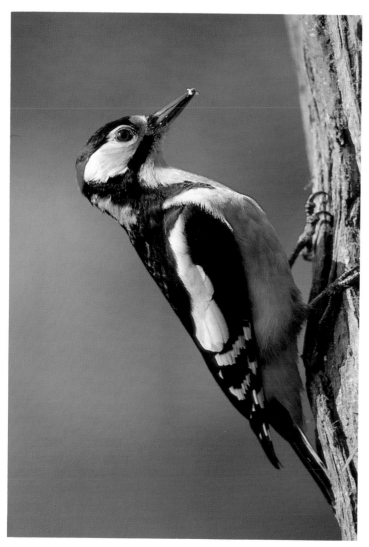

**Great Spotted Woodpecker**

Pinewood, Speyside

14

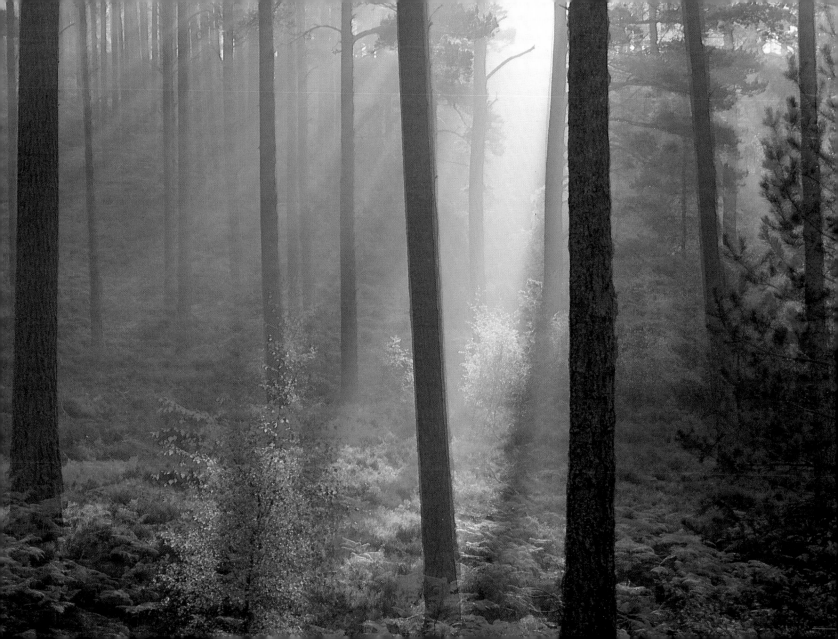

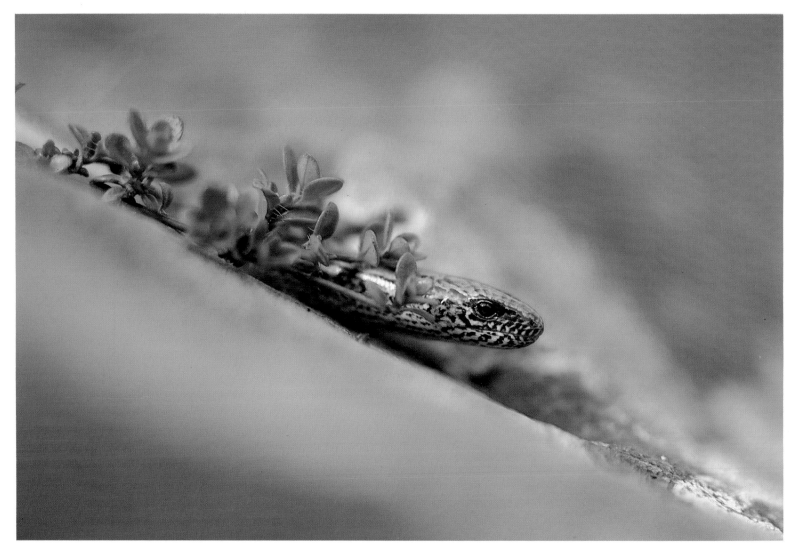

**Slow-worm**

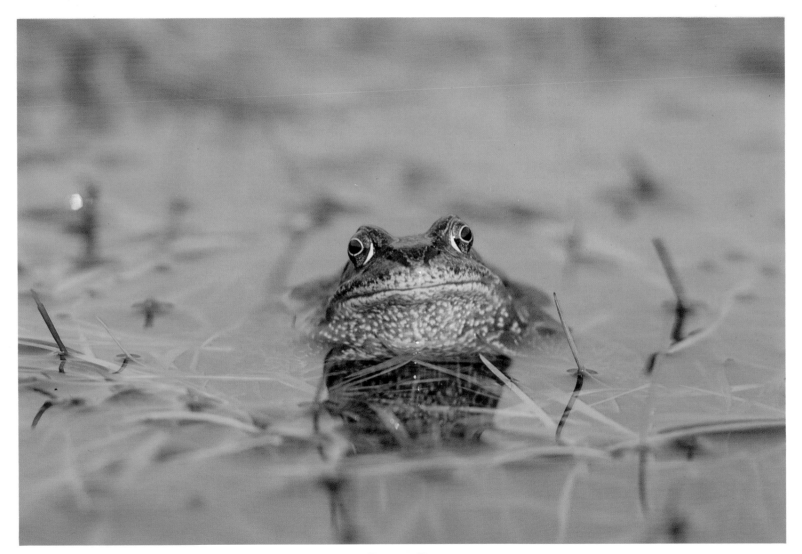

**Common Frog**

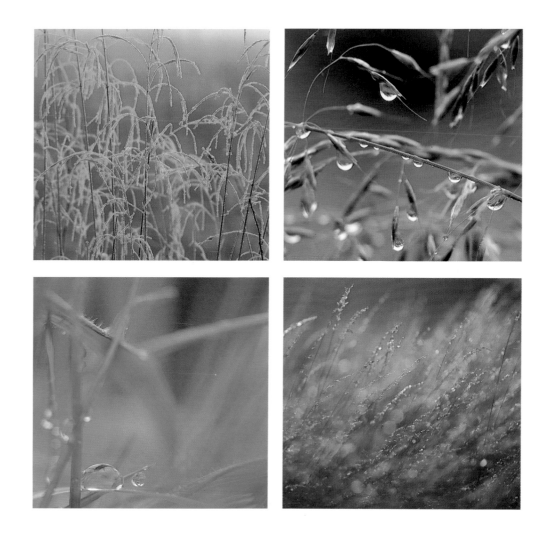

# Grasses

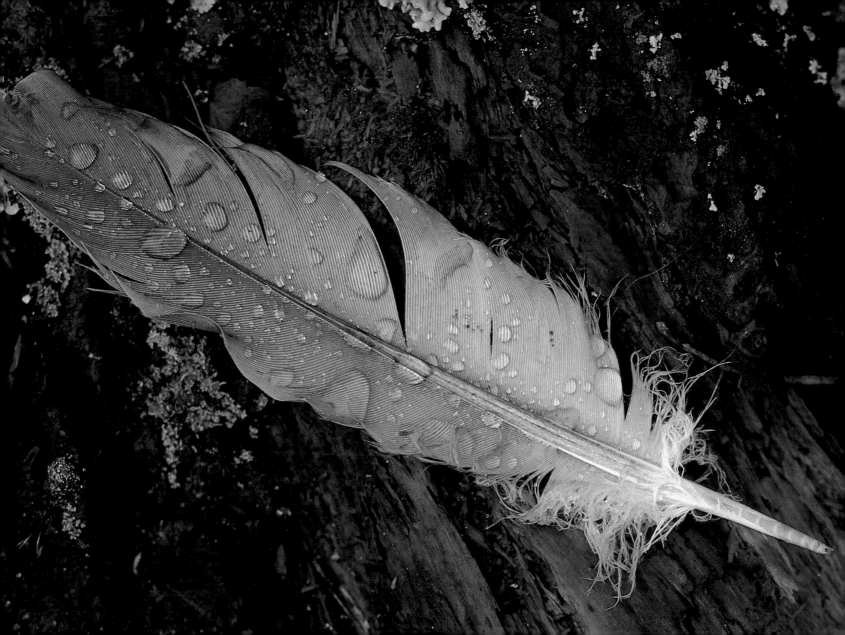

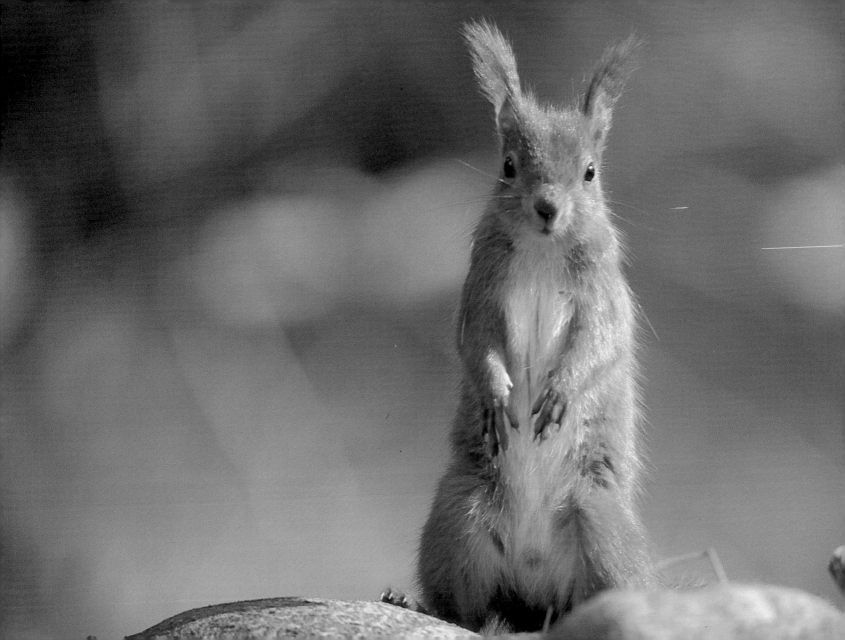

# Fifty pounds of hazelnuts

Often, while waiting in an old pinewood on Deeside, I would catch a fleeting glimpse of a red squirrel hurrying along the topmost branches of the trees. Such a sight always set me thinking about the best way to catch these elusive creatures on film. With a subject whose movements are almost entirely unpredictable simply waiting around, even for lengthy periods, is not enough to ensure results. To swing the odds in my favour I decided that I would have to attract the squirrels by using bait.

I chose a location nearer home and arrived, one frosty January morning, armed with a bag of hazelnuts. I knew squirrels lived in these woods and my first task was to select a suitable site for a hide. I chose a spot about halfway down a bank, at the top of which stood a very old and impressive beech tree. Using branches and other natural materials I constructed the hide. From this position I could get a ground-level view of the tree's immense moss-covered roots, in the midst of which stood the stump of an old oak tree. Before leaving I placed a few handfuls of nuts on the tree stump; reasoning that the

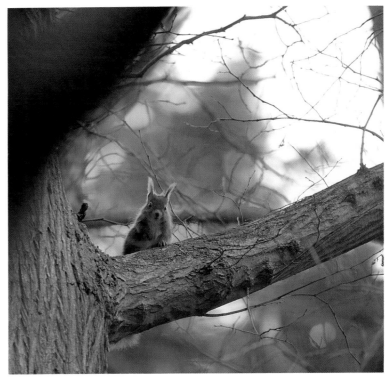

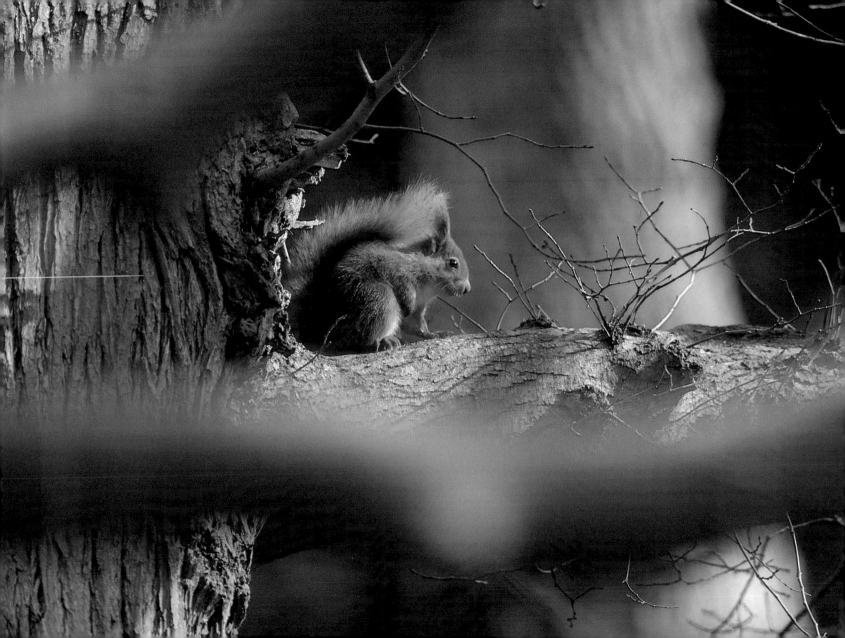

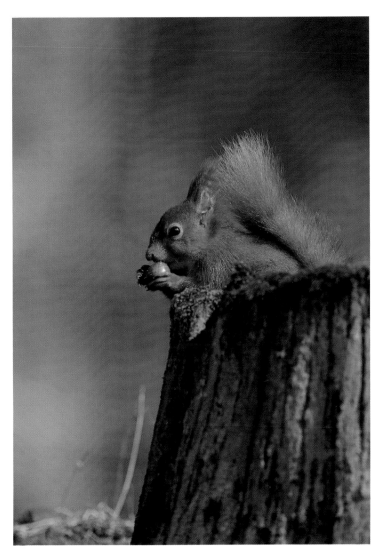

squirrels would be more at ease if they had a good lookout point while feeding.

Over the next six weeks children from a nearby farm visited the site two or three times a week and replenished the nuts. By late February about two pounds of hazelnuts were disappearing every week and I decided it was time for my first session in the hide. Snow lay thick on the ground that day, and after a seven hour wait I had seen no sign of the squirrels. Only the half-mile tramp back to the car relieved the numbness in my feet.

Baiting continued throughout March, with the nuts disappearing faster than ever. Close inspection revealed empty shells with a neat round hole gnawed in each; it seemed that the local vole population was benefiting most from our generosity. By the end of March I had spent a total of eleven days in the hide, with very occasional sightings of squirrels, but never in the vicinity of the tree stump.

By mid-April I was on the point of giving up. Soon other food would become available in the wood and it would be pointless to continue with the baiting. I decided to pay one last visit to assess the situation. Immediately I was excited to find that a few hazelnuts had been split in half – a sure sign that a squirrel had been at work – and within ten minutes I had put out a fresh supply and was in the hide. It was now almost eleven thirty – much later than I had ever entered the hide before. Midday passed and life in the wood returned to normal. My confidence increased when a woodpigeon glided down to the base of the beech tree and spread its wings to sun itself. Then, through a small hole in the roof of the hide, I noticed a squirrel's tail sticking out from a fork in the beech. Through the camera I could tell that it was about sixty feet up, and sound asleep.

Twenty minutes passed before the squirrel woke up, yawned, stretched, then looked down in the direction of the nuts. I was still adjusting the camera when the squirrel leapt onto the stump, picked up a nut, fumbled with it until it had a good grip with its mouth, then scampered out of view behind a blackthorn thicket. To my relief it returned within a few minutes and this time it ran off in another direction. The performance was repeated again and again and I realised that the bait would be finished before I had all the pictures I wanted. I waited until the squirrel was well out of sight before slipping from the hide and scattering my entire stock of nuts around the tree stump. I was back in position before the squirrel returned and by five o'clock I had taken seven rolls of film. Meanwhile the squirrel had collected, one at a time, over two pounds of hazelnuts – each one carefully hidden away for harder times.

Near Coldstream
January-April

Resin on Scots Pine

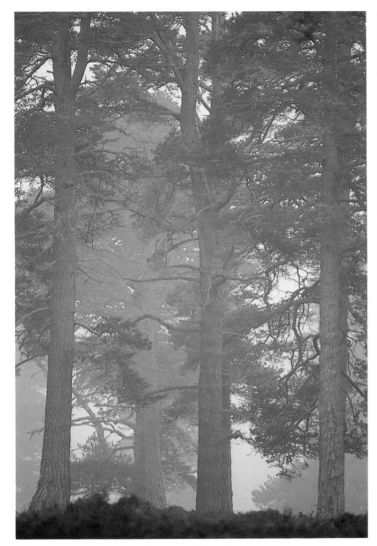

Pinewood, Deeside

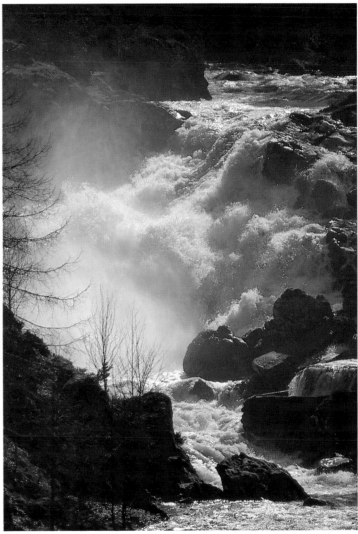

River Muick

Osprey

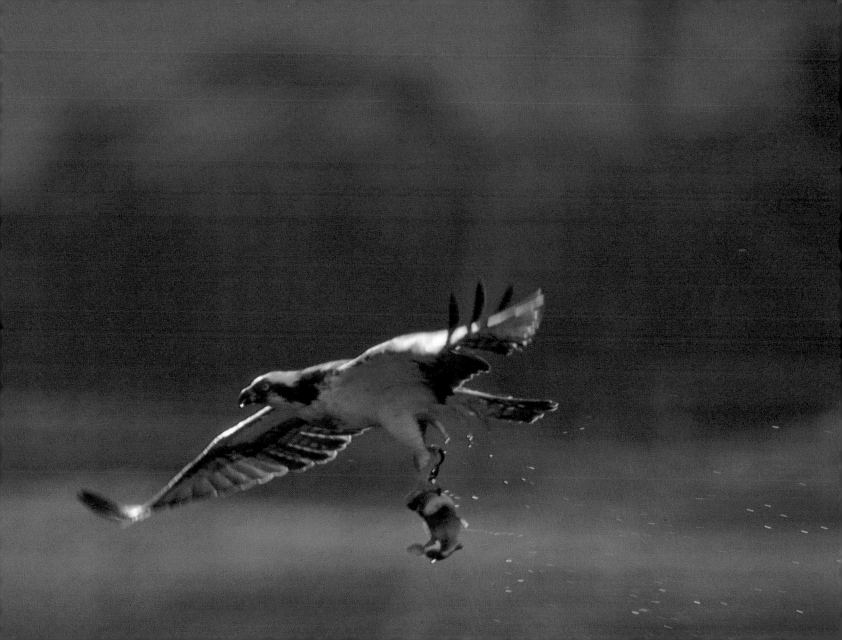

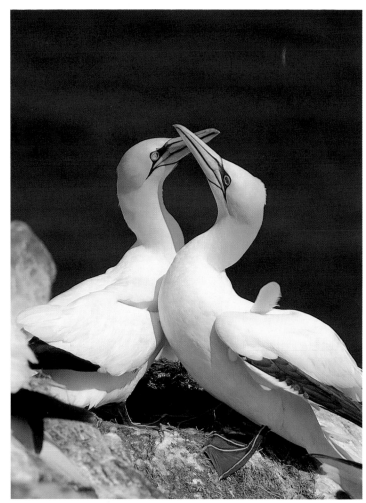

**Gannets on the Bass Rock**

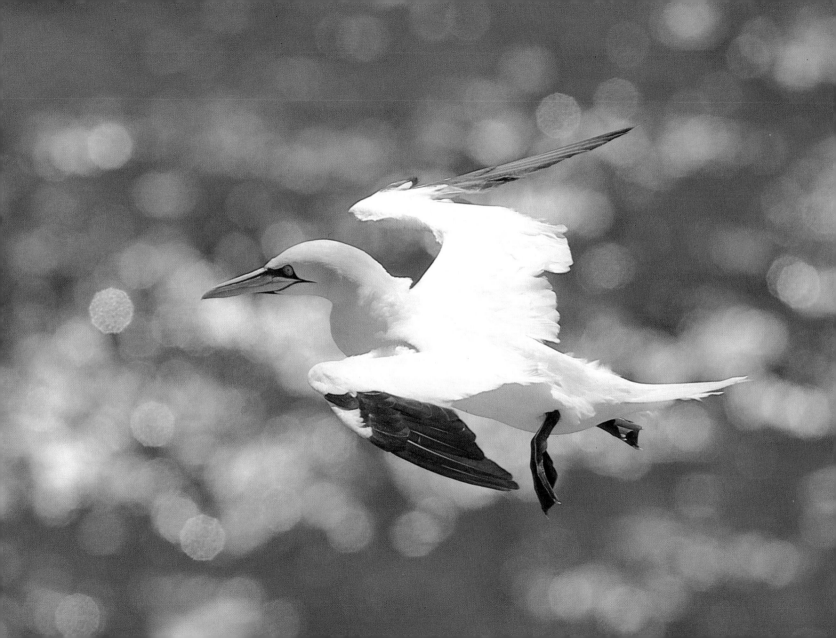

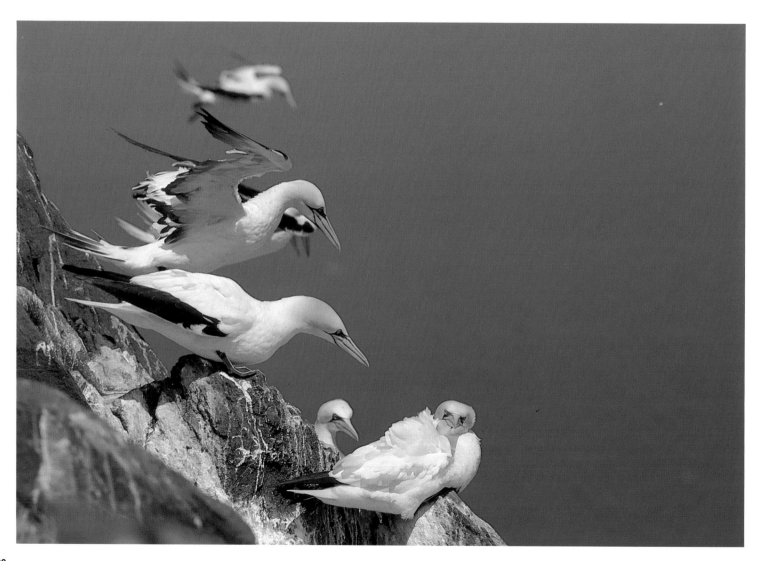

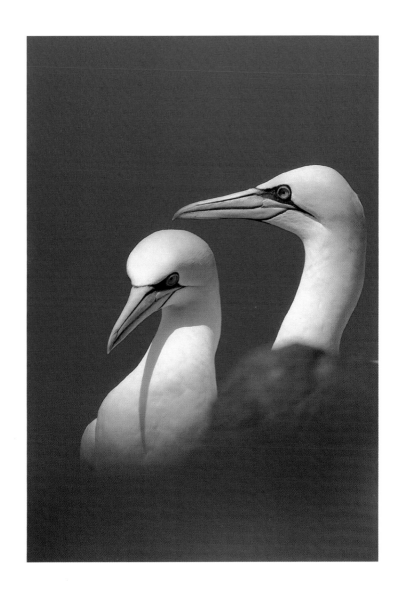

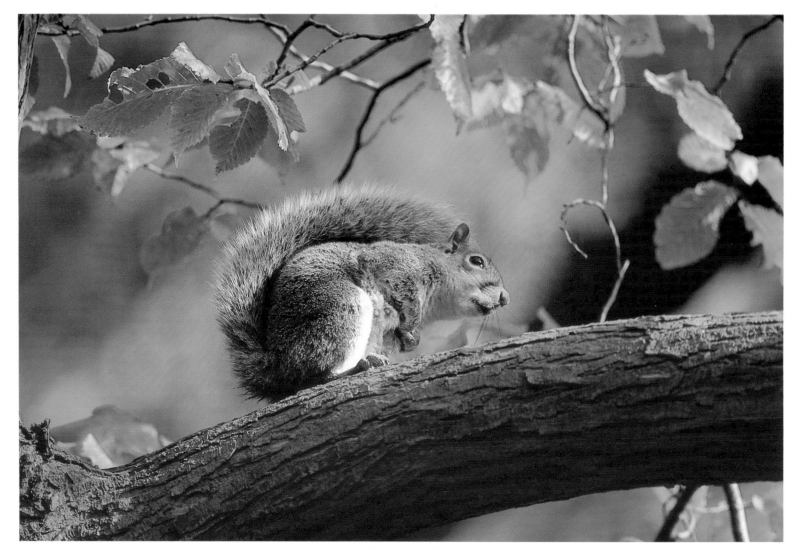

**Grey Squirrel**

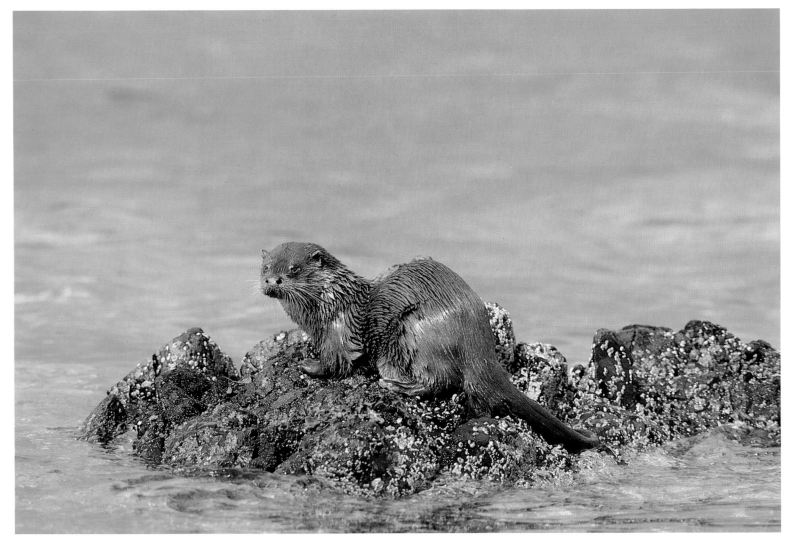

Otter

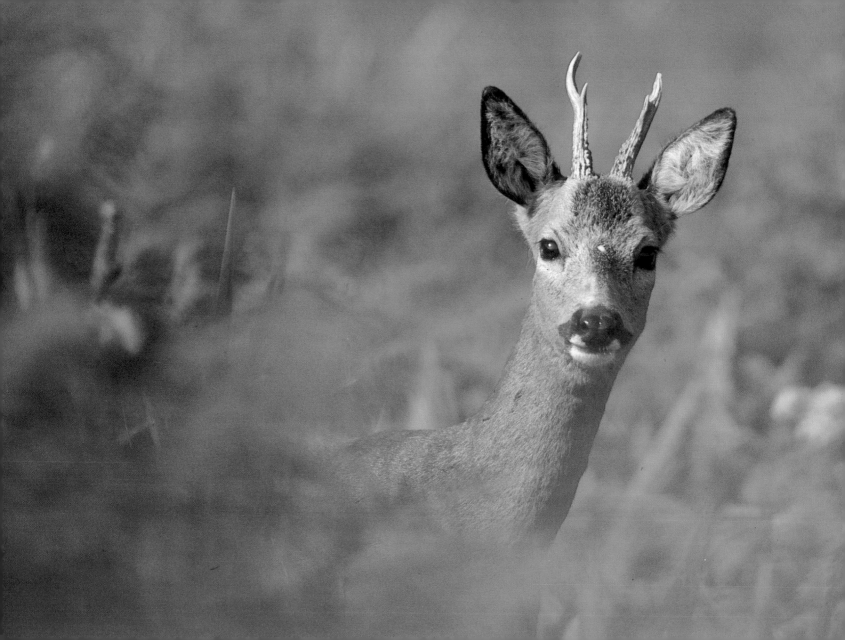

# A surprise encounter

It was July and, after a busy Spring season, I had gone out in search of some general pictures. I was lying beneath a tree at the edge of a peat bog, waiting for the sun to set a little lower in the sky so that I could photograph a patch of cotton grass. I had pre-visualised that the delicate heads of the grasses would be best captured in low-angled light, and against the dark shadows of a nearby block of pine trees. By about seven o'clock a gentle breeze was blowing in from the direction of the sea behind me. Standing up to have a look around I saw a roe deer grazing in the lusher grass at the far end of the peat bog. I immediately ducked down again, thinking myself lucky that, as far as I knew, the deer hadn't spotted me. From what I had seen the animal appeared to be a young buck in its full, reddish brown, summer coat. I judged that it was working its way in my direction and that at any minute it might catch my scent. Preparing my camera I moved stealthily towards a patch of bracken which lay to one side of the approaching deer.

For five long minutes I resisted the temptation to look up. I was now relying entirely on my original sighting in order to continue with the stalk. As I waited I remembered only too well how, on similar occasions, I had given the game away by looking up too soon. I began to creep forward on my hands and knees, pausing when I had covered about ten yards. My pulse was racing with excitement as I scanned the undergrowth for a sign of movement. Then, from about fifteen yards ahead, I heard a brief rustling sound. At first I thought it was a rabbit or some other animal, and that I couldn't possibly be so close to the deer; but through the blur of the out-of-focus vegetation I could just pick out the shape of the grazing roebuck in my viewfinder. I doubted whether in my excitement I would be able to hold the camera steady so I switched to a faster shutter speed. I stood up very slowly. The deer noticed me at the same moment, and together we rose above the bracken. As.soon as I had a clear view I released the shutter, catching a look of surprise from the buck before he galloped off in alarm. Fifty yards further on he paused, as deer often do, to look back at me. Then he was off again, barking a gruff warning to others of his own kind as he disappeared into the trees.

Ardnamurchan Peninsula
Argyll
July

Robin

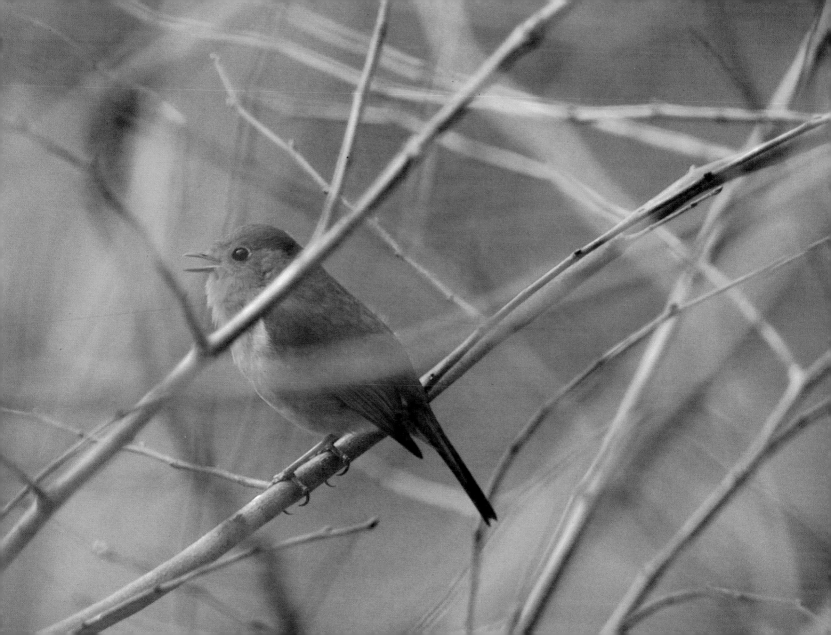

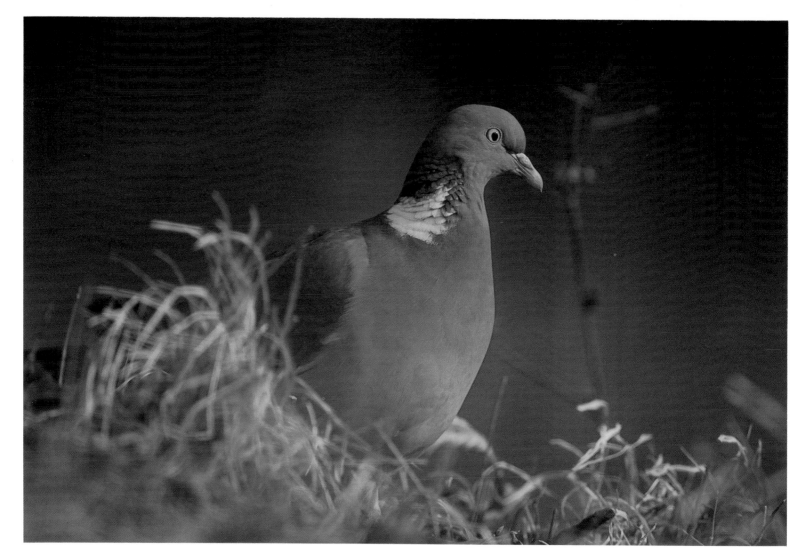

**Woodpigeon**

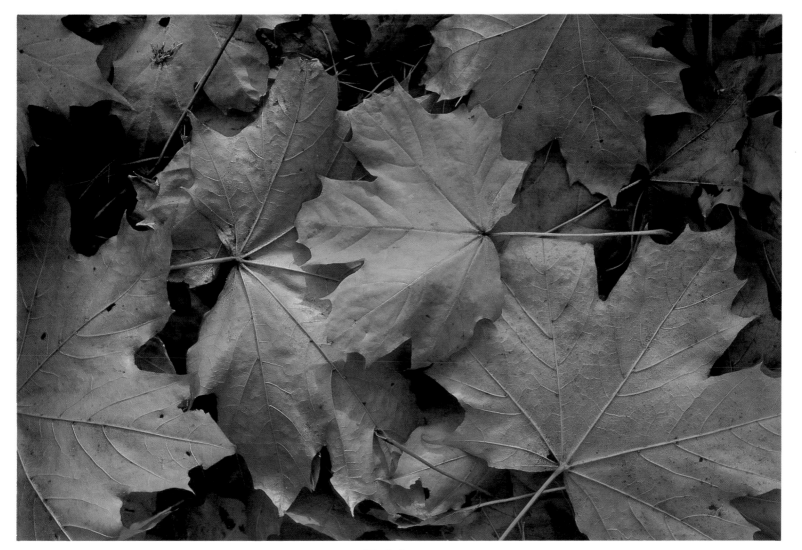

**Maple Leaves**

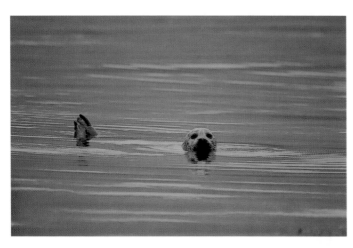

# Common Seal Diving

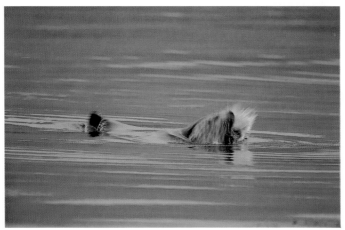

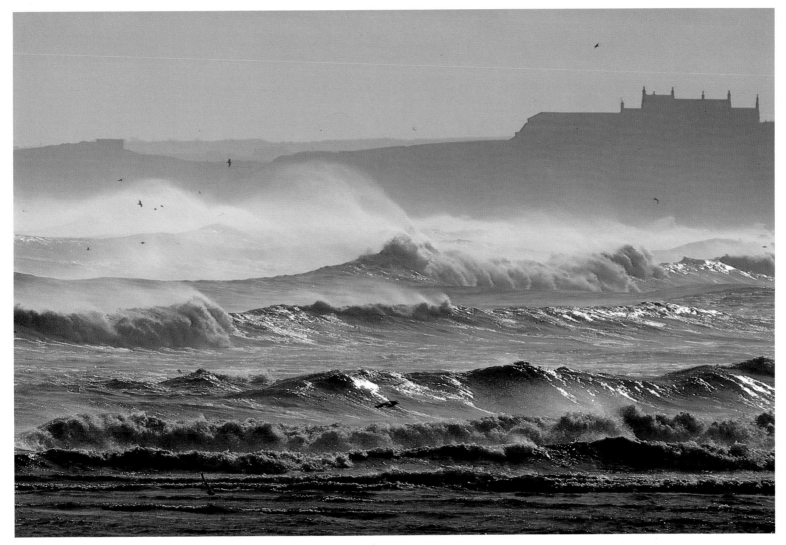

Seascape, Berwick

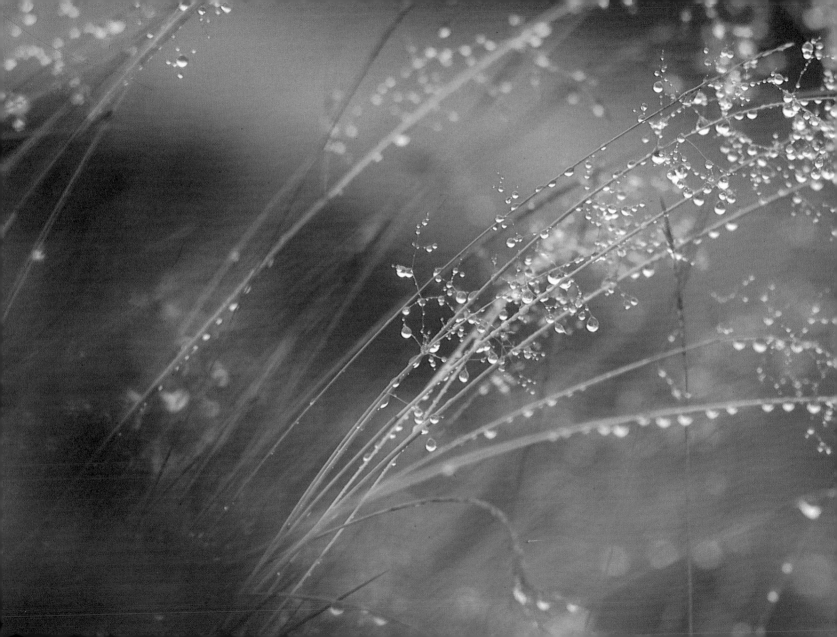

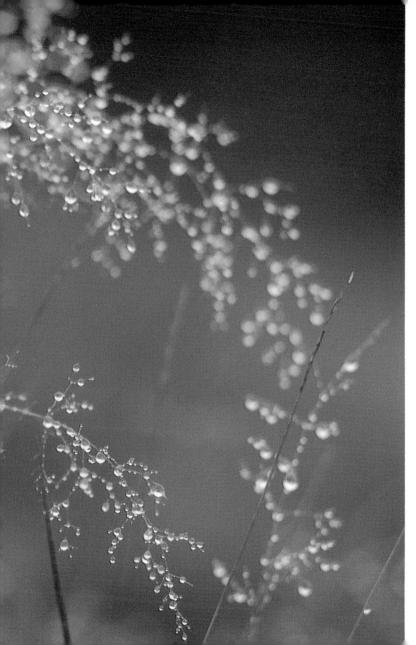

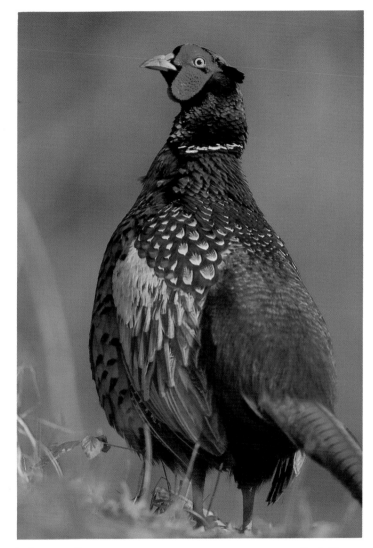

**Raindrops on Grasses**

**Cock Pheasant**

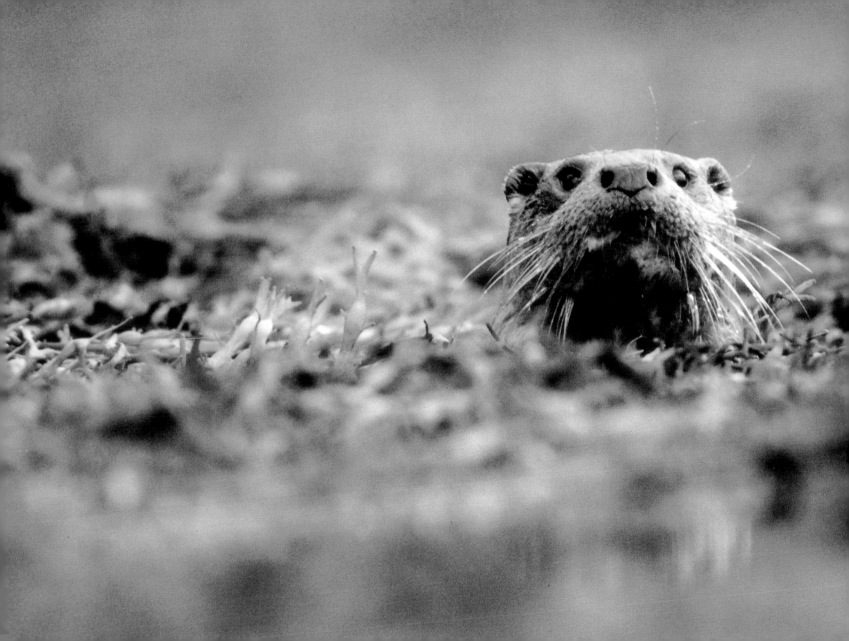

# Otters in a rock pool

I had spent an uncomfortable night under canvas and just after first light I returned to the car for breakfast. The grey cloud cover was breaking and the rain seemed to be falling less steadily as I looked out across the bay. A few hundred yards offshore I noticed a dark object that seemed to be swimming towards me. Through the binoculars I saw, to my delight, that it was an otter. I immediately forgot about breakfast, reached for my camera, and within minutes was down by the high-water mark. There was no wind and the tide was coming in slowly as I watched the approaching otter from behind a screen of yellow iris foliage. Thirty yards away it stepped out of the sea, carrying an eel. After a quick shake it bounded off along the shore.

I wondered why it hadn't stopped to eat the eel, but was more concerned about the fact that there was little cover to allow me to follow. I waited until it had rounded a large rocky outcrop before moving from my position. I made my way carefully, trying to avoid stepping on patches of loose shingle, while keeping my eye on the spot where the otter had disappeared. Slowly easing myself over a grassy bank I looked around. There was no sign of the animal – which did not surprise me since I knew that otter stalks can end very abruptly, these shy creatures having the ability to disappear almost by magic. I decided there would be no harm in waiting for ten minutes in case it reappeared. A pair of rock-pipits entertained me as I waited, working their way diligently along the upper shore as they searched the rotting seaweed for fly larvae.

Shortly my attention was drawn by a vaguely familiar sound coming from behind some large boulders about twenty yards ahead of me. After a frantic search through my mental index of animal noises I compared it to the sound of badger cubs at play. Everything now fell into place. The otter had not eaten the eel because she was taking it back for her cubs. I prepared myself for a long wait, confident that I was onto something special. After three hours a wind arose, forcing me to change position in case the otters picked up my scent. I took the opportunity to rush back to the car for extra clothing and spare film, then settled again, about thirty yards from the holt. A large boulder acted as a suitable back-rest and disguised my outline. A further two hours passed and I began to wonder whether I had alerted the family while moving position – perhaps, I reflected, they were now watching me.

A black guillemot was diving in the shallows and I watched it with interest. Each dive lasted about forty-five seconds, averaging about a one-in-five success rate. The tide was now ebbing and I had heard no sounds from the holt for some time. Suddenly I caught sight of the female otter with a cub following her. Now that her coat had dried she looked much bigger; the cub, in comparison, was about one-third of her length. Every now and then she paused and looked back at the youngster as it struggled over the large rocks. She raised her head and I thought for a moment that she had caught my scent, but then I saw a second cub not far from the holt. Obviously distressed and

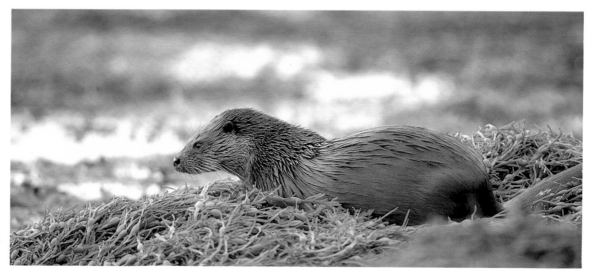

feeling abandoned, it was whistling plaintively for attention. The mother doubled back for it and soon all three were making their way down to the lower shore.

Using the boulders for cover I made my way cautiously to where I could hear the family playing. Peeping over a rock shelf I saw, about thirty feet away, a ball of otters rolling over and over in a pool. Every now and then a head would pop up, followed closely by a tail flipping over. I had difficulty telling where one otter began and another finished. The female swam underwater to the far side of the rock pool, leaving a wake of air bubbles breaking on the surface, then, with a brief glance back at the cubs, she clambered out and made her way to a neighbouring pool. The cubs fell silent, aware of their mother's departure, their heads bobbing above the surface as they searched anxiously for her. They swam to the edge of the pool and climbed out.

Soon the female reappeared with a small butterfish which was promptly grabbed by one of the cubs. As the other attempted to snatch it a tug-of-war developed, each cub pulling away with forepaws braced and back arched. Suddenly one cub lost its footing and tumbled back into the pool – minus the fish. The victor, head held high, rapidly crunched the fish along its length before swallowing it whole. By now the female was back in the other pool and was hunting in the partly-

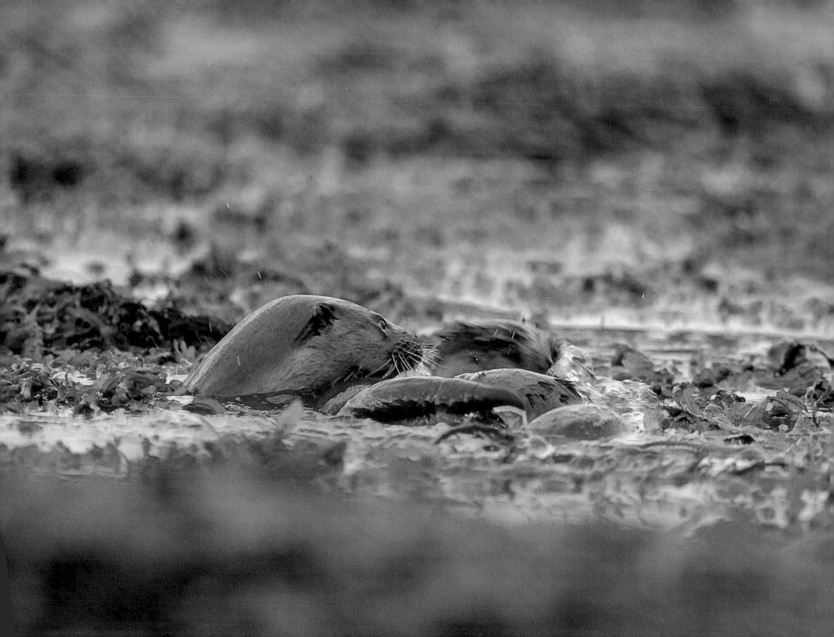

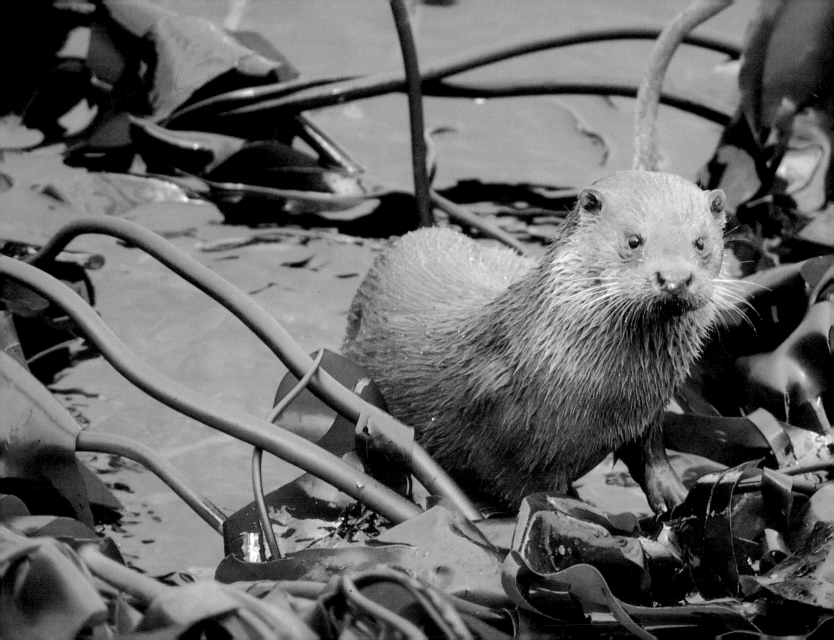

submerged tangle of kelp, her position betrayed by the bobbing weed. I took this opportunity to get closer. Keeping low, I waded through the pool with water rushing in over the top of my wellingtons. As I did so the sun came out from behind a cloud and I realised I would have to approach from another angle in order to avoid problems with the light. As I was circling the pool, using a weed-strewn gully for cover, I suddenly came face to face with the adult otter. I froze, hardly daring to breathe, then, in a flash, she bounded back to her cubs. Slowly I sat down. The bubble had burst and I felt sure I would see no more of the family for the rest of the day.

I removed by cameras, noting with satisfaction that I had managed to take over twenty photographs of the otters, and began to empty the water from my boots. As I poured the water onto the ledge below I noticed a sea-urchin grazing on a kelp frond in the water. This was a subject I particularly wanted to photograph so I pulled my boots back on and jumped down to investigate. I landed heavily and was startled as the female otter rushed out from beneath the ledge, brushing my leg as she passed, before diving into the sea. Until then I had not appreciated the size of the beast; I estimated her to be fully three and a half feet long. She surfaced about twenty-five yards out and watched me from beneath a veil of weed. After coughing

loudly at me she dived again, only to resurface a little further out. I turned to look down at the ledge, parting the screen of hanging bladder wrack before receiving a second shock as one of the cubs shot out and promptly attacked the heel of my boot, hanging onto it like a terrier with a rat. I stood disbelievingly as the cub chittered and shook its head, its nose wrinkled up, with whiskers sticking out at all angles. Looking under the ledge I saw the second cub, obviously of a more easy-going disposition, glaring up at me. The assault on my heel abated and I took the opportunity to escape, worrying that perhaps I had already upset these sensitive animals too much. I felt that any further attempts to take photographs would have been cheating.

At a safe distance I rested by a large rock and took up my binoculars. I watched with relief as the female swam ashore to be reunited with the cubs who greeted her with excited whistles. Soon, and with some urgency, the whole family set off in the direction of one of the islands further along the loch. I watched all three land safely then disappear from view behind weed-covered rocks. Presently a pair of oyster-catchers rose into the air piping their alarm call. I could only presume they had been disturbed by a family of otters.

Mull
September

**49**

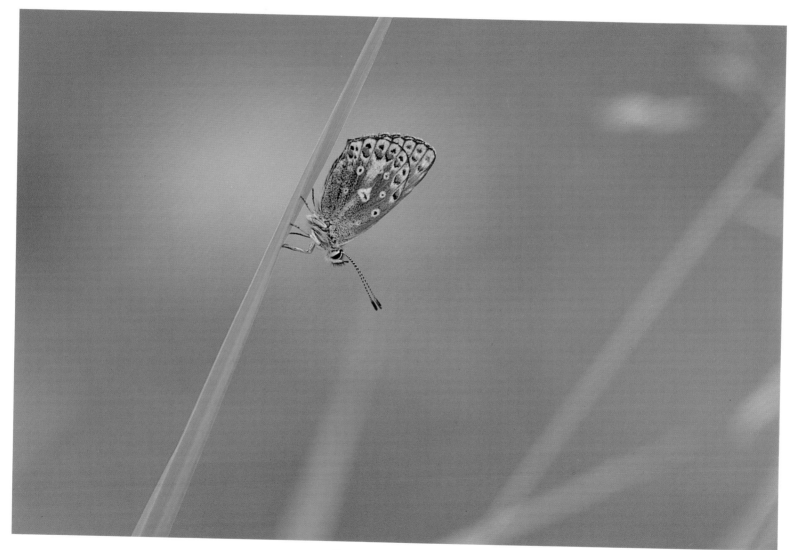

**Common Blue Butterfly**

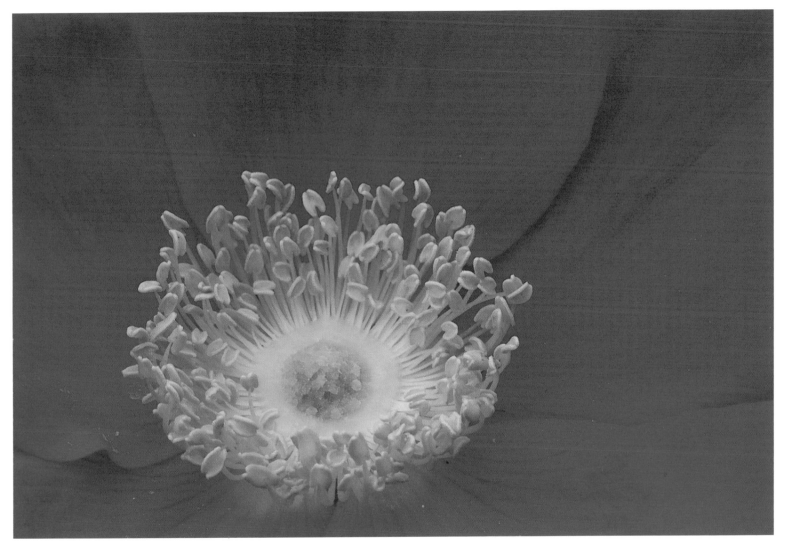

**Provence Rose**

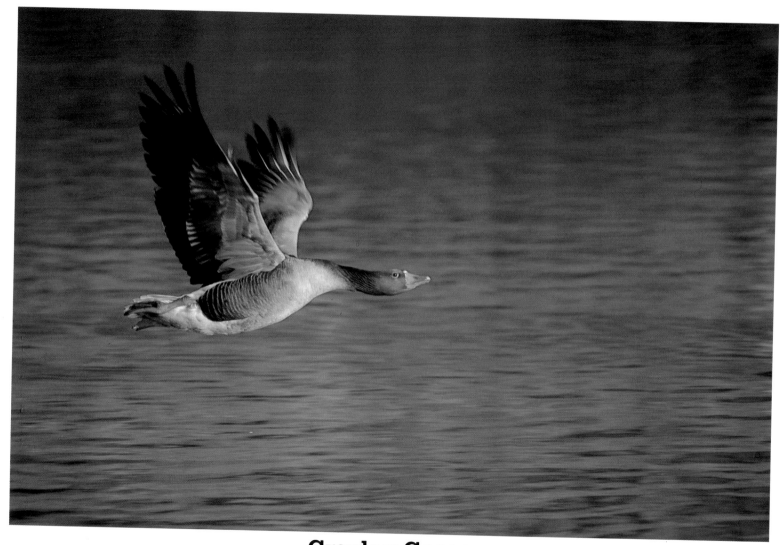

**Greylag Geese**

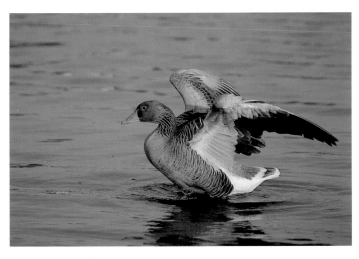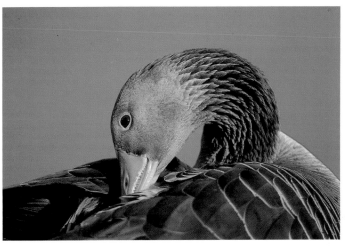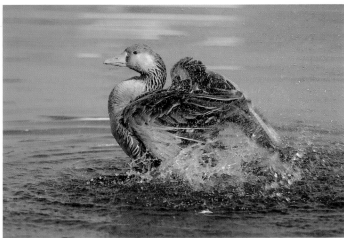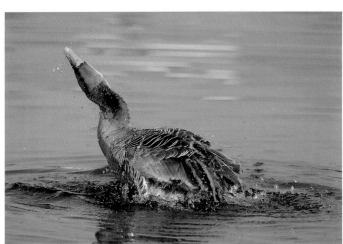

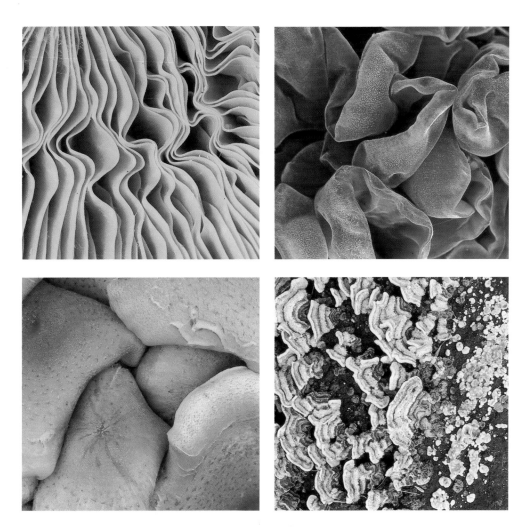

# Fungi

Milkcap *top left*. Jew's-ear *top right*. Shaggy Pholiota *above left*. Hairy Stereum *above right*.

# Inside an elm tree

It often happens that when I am looking for a certain subject to photograph I find something else which proves to be equally interesting. On this occasion I was searching a wood for a tawny owl's nest site when, instead, I came across a jackdaw's nest. It had been built inside a hollow elm tree and had two entrances – one where the main trunk had snapped off, revealing a vertical shaft about twelve feet deep; and another, smaller, entrance in the side where a branch had died and rotted. I immediately realised that there was a possibility of getting some unusual pictures of the birds inside the tree.

I was not, however, entirely confident of success. Jackdaws, like other members of the crow family, are noted for their intelligence. They are also very wary, probably because they are still persecuted for their predation on young game-birds, but I decided nevertheless to proceed with my plan.

I waited until the chicks had hatched and were about a week old before beginning to build a platform against the trunk at a point where I estimated the nest to be. Over the next two weeks I completed the platform and built a hide over it – made from dark, heavy duty canvas, on a wooden framework. This now enclosed the portion of the trunk where the nest lay. Lastly I cut a hole in the trunk, about eighteen inches high and ten inches wide, which gave me a side-on view of the nest. Inside, the four chicks watched these developments with interest, crouching close together in their nest of twigs and sheep's wool while the anxious parents called in alarm from a nearby tree. Finally I tacked a double layer of canvas over the hole and left. I watched from a distance and was pleased

to see an adult bird return with a beakful of earthworms.

I allowed four full days to elapse before returning to the hide. Having first set up my camera and flash equipment I removed the canvas from the hole and began my observations of life inside a tree. From my seat in the gloom I could see that the chicks had settled down. Occasionally one would get up, stretch, and exercise its wings – sending out clouds of dust and feather down which were highlighted in the rays of sunshine filtering down from above. After about twenty minutes it began to get very hot in the hide. At this point I was hoping

that the adults hadn't been frightened off; then, without warning, all the chicks sprang to their feet and began calling loudly. Seconds later one of the parent birds landed in a heap on the nest, sending a gust of stale air through the hide. After its rather unceremonious entrance the adult quickly collected itself and shuffled to the edge of the nest. The young birds closed in, the hungriest one clamouring above the rest until it was subdued with a large beetle. The others seemed to realise there was no more food to be had and instantly stopped their calling. The parent relaxed a bit, rearranged a stray twig, then, apparently satisfied that

all was in order, squatted down before thrusting itself vertically upwards into the daylight.

Despite the heat and the discomfort I stayed on in the hide much longer than I really needed to. This was partly to avoid disturbing the birds any further, but mainly because I was fascinated by the sight of this family going about their daily business only a few feet away from me.

Lamington, Lanarkshire
April-June

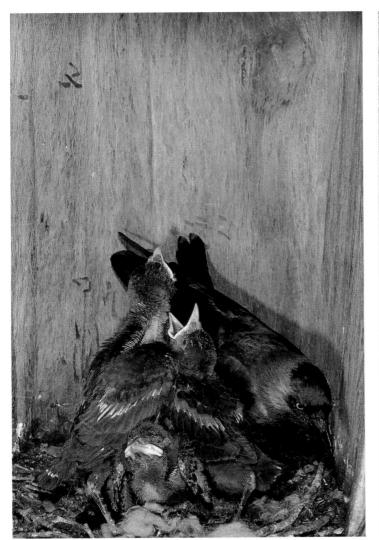

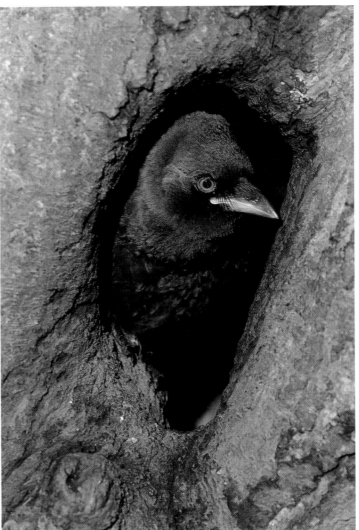

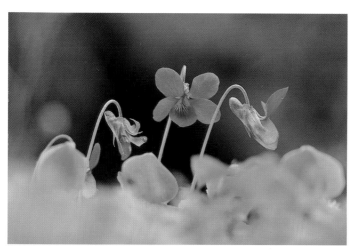
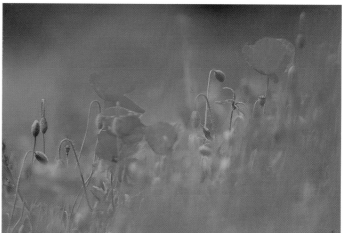
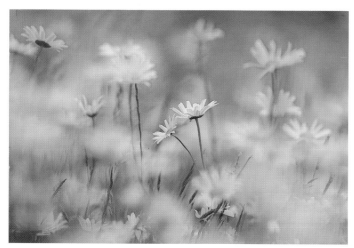
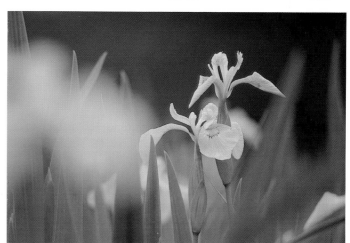

# Wildflowers

Common Dog Violets *top left*. Common Poppies *top right*. Ox-eye Daisies *above left*. Yellow Iris *above right*.

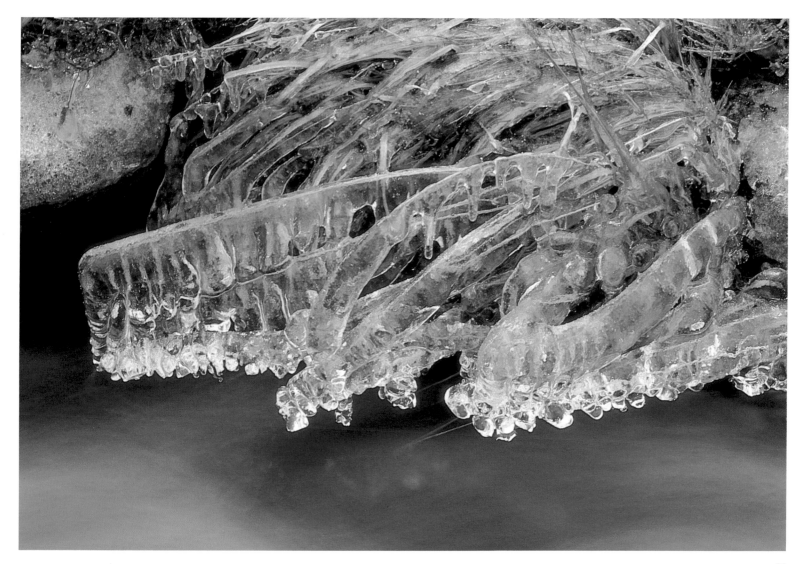

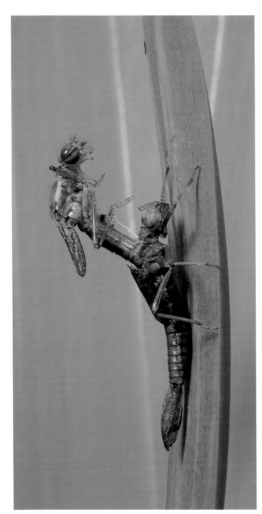 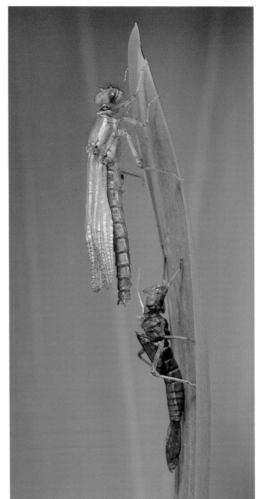 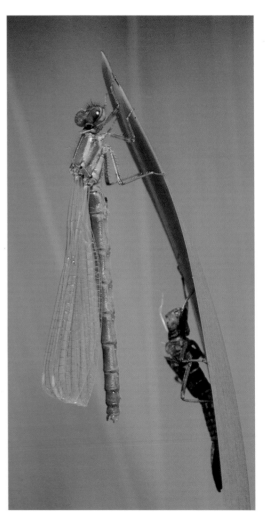

# Damselfly Hatching

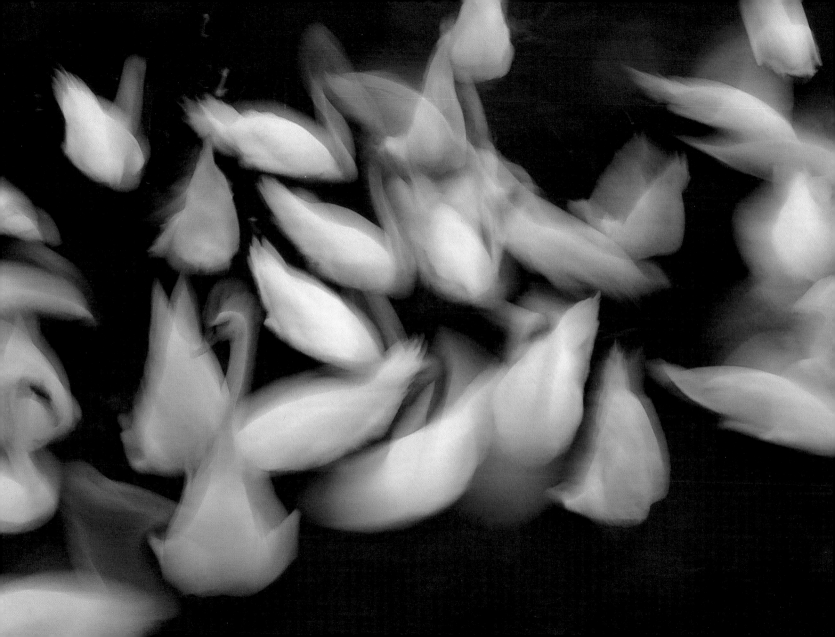

# Badger-watching

Badgers are much more common than most people realise. This is mainly because they are nocturnal creatures; and while it is reasonably easy to find their living quarters, it is much more difficult to observe the animals themselves.

One badger sett which I know particularly well, and have watched for over fifteen years, is typical in layout. It is situated at the top of a bank along which grows a mixture of elm and sycamore trees  Large mounds of earth, excavated in the dry, sandy soil, mark the entrance to each burrow and give a clue to the extent of the tunnel system which lies underground. This is a long-established sett and has over twenty entrances – although not all of them are in regular use at one time. Above ground the badgers have created a

network of well-trodden pathways which lead to favoured feeding areas and to and from the main entrances.

Badgers have a particularly acute sense of smell and, in order to watch them undetected, I was forced to build a hide about twenty feet above ground; between three elms growing close together at the top of the bank. From this vantage point I could look onto a small part of the sett, used for many years by an old female to give birth to her cubs.

The cubs are born underground early in the year and do not emerge from the burrow until the latter half of May. At this time I like to be settled in the hide at least an hour before sunset. As darkness gathers other woodland animals become active. Rabbits come out to nibble the grass in a nearby field, and loud sniffings and rustlings betray the presence of a hedgehog searching the leaflitter for slugs and earthworms which become more plentiful as the evening dew increases.

An hour or so later details on the ground have become more vague. I concentrate my attention on the entrance to the burrow, from which I can occasionally hear the faint thumping noises of cubs playing in the tunnel. Soon the female's unmistakeable black and white striped face comes into view, nose held high as she quietly sniffs the air for any strange scents. She checks each

direction thoroughly before withdrawing again. Ten minutes later she reappears and I can hear impatient chittering sounds coming from the burrow. She emerges fully, then casually leans back and begins to scratch with her hind leg, thumping on the ground like a dog on a livingroom floor. Almost at once the two cubs appear, each of them about half the size of the mother and a perfectly proportioned miniature of her. I guess from the way they play, and their familiarity with the surroundings, that this is not their first time above ground. After some hectic chasing round and round their mother they charge off into the long grass and disappear from view.

I return to the sett nightly for about a week. On several occasions I come across the cubs when I am on the ground and I find that if I stand quite still they will sniff and investigate my boots before heading off in their original direction. After a month my visits are less frequent and the cubs are losing much of their trust, regarding me now with suspicion. As the summer nears an end they range farther and farther afield; occasionally staying overnight in one of the smaller 'satellite' setts as much as a mile away, and gradually adapting to the mysterious, nocturnal life of the adults.

Near Paxton, Berwickshire
June

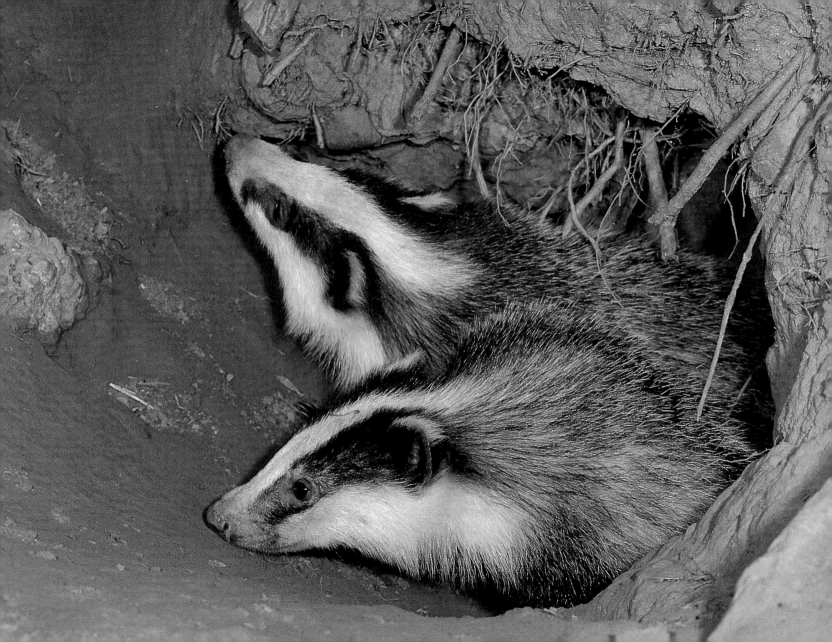

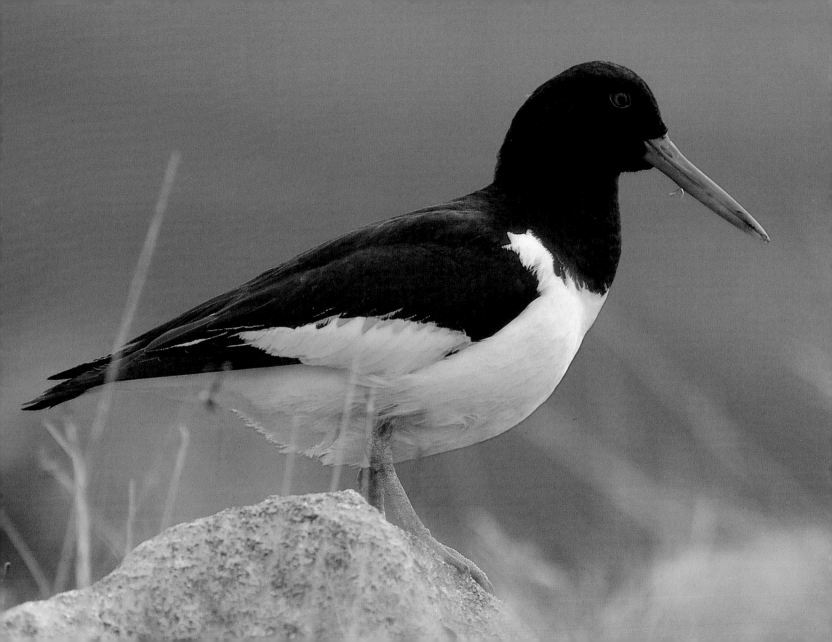

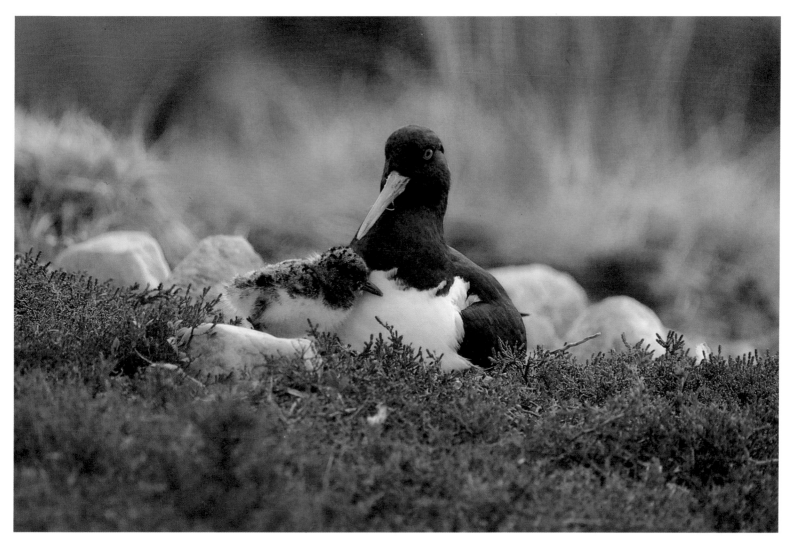

# Oyster Catchers

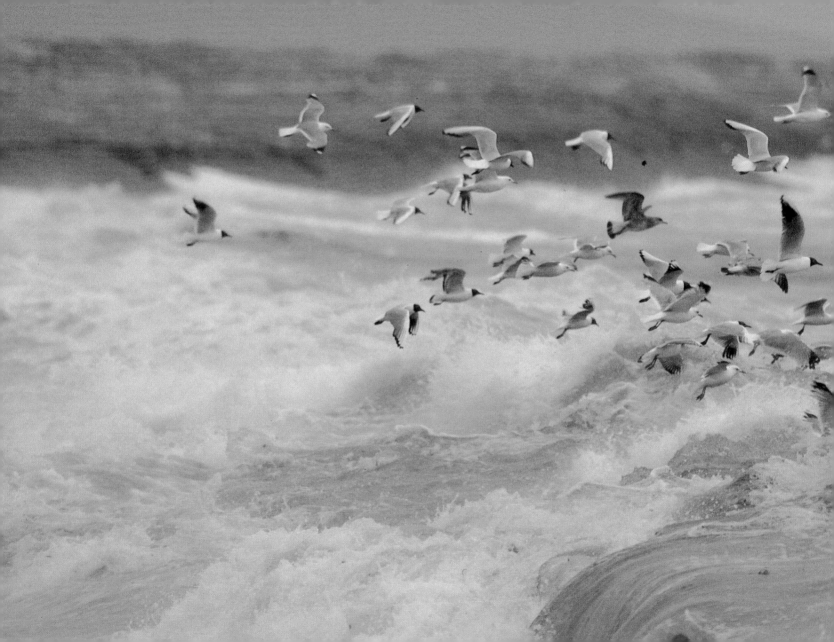

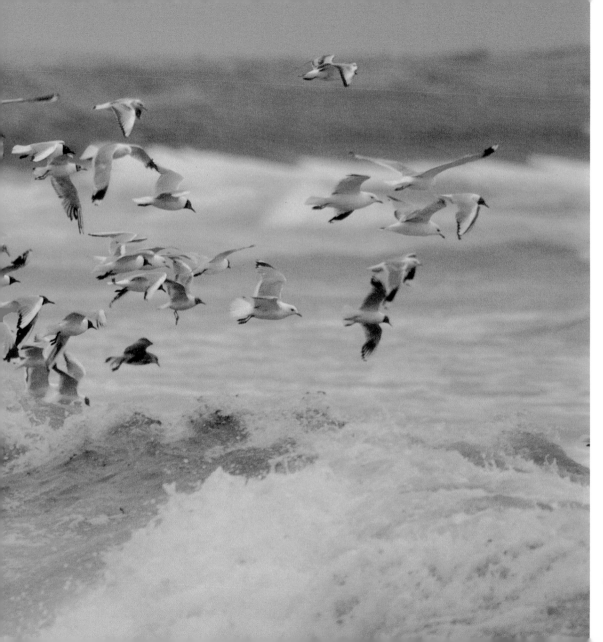

Gulls in Surf

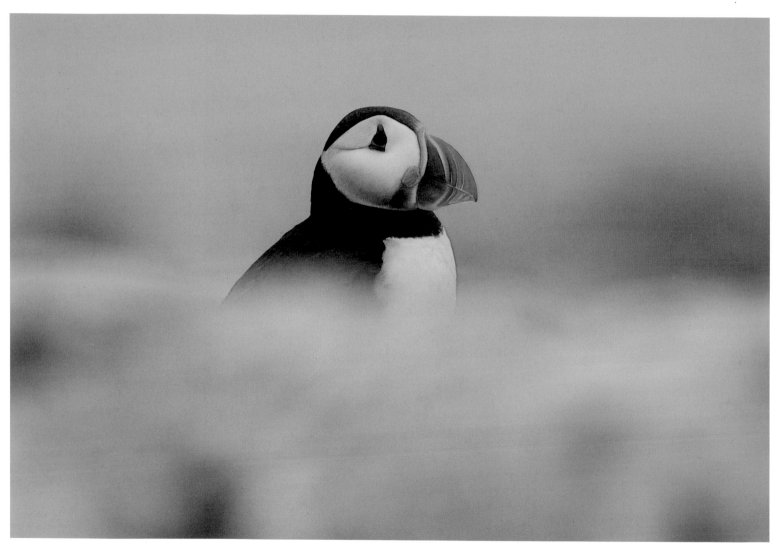

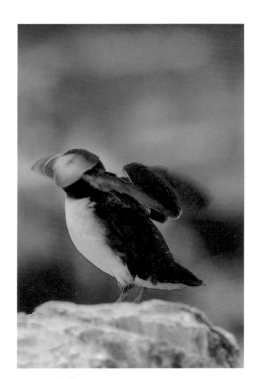
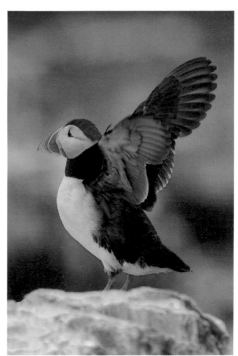
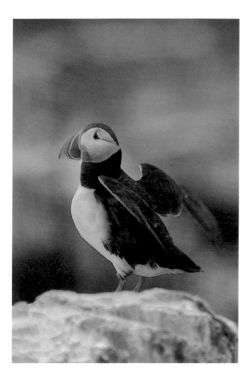

# Puffins

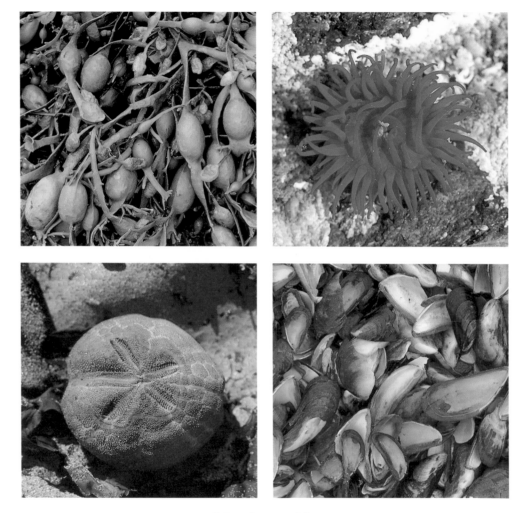

# Marine Life

Knotted Wrack Seaweed *top left*. Beadlet Sea Anemone *top right*. Purple Heart Sea Urchin *above left*. Mussel Shells *above right*.

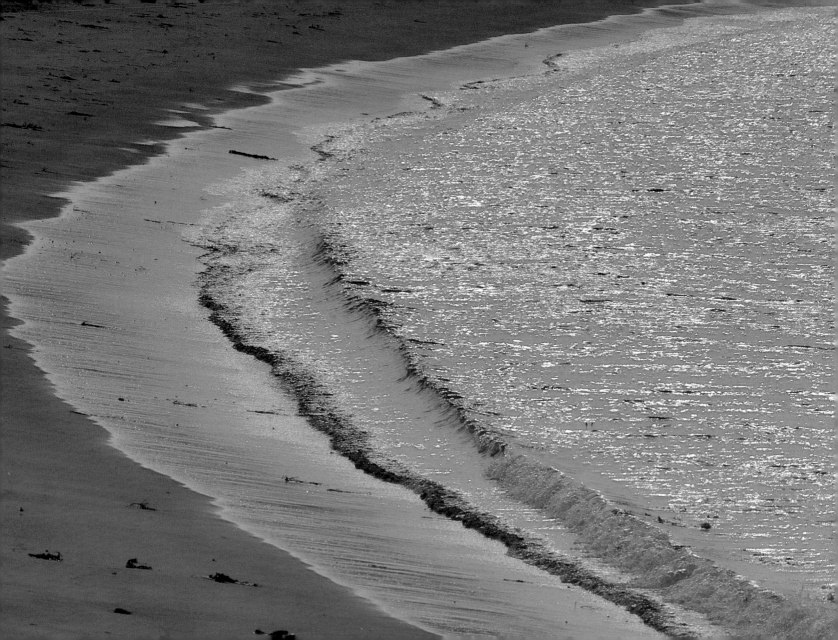

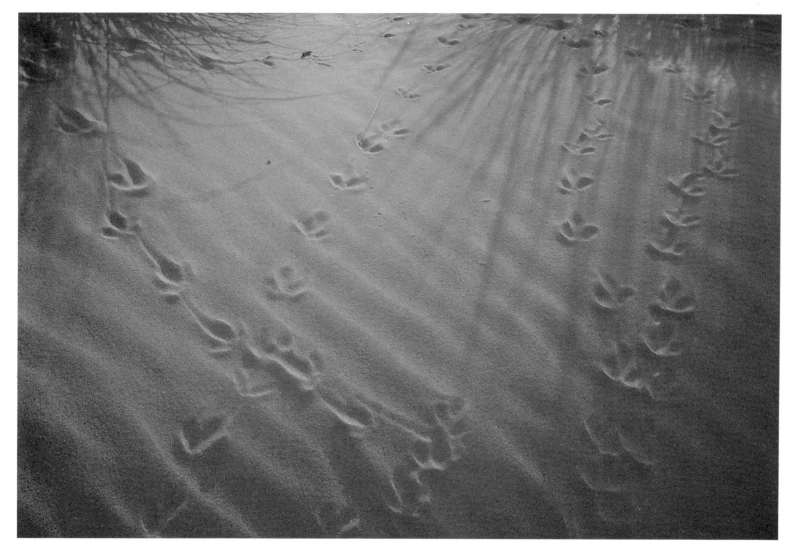

**Footprints**

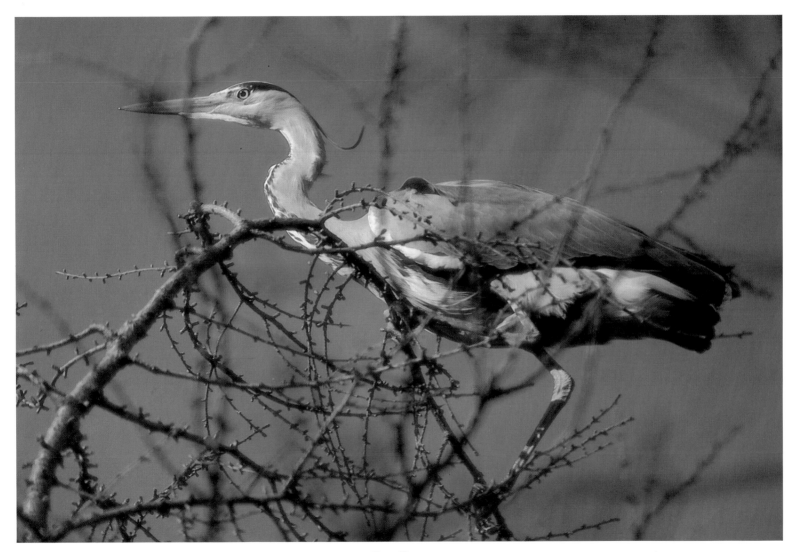

**Grey Heron**

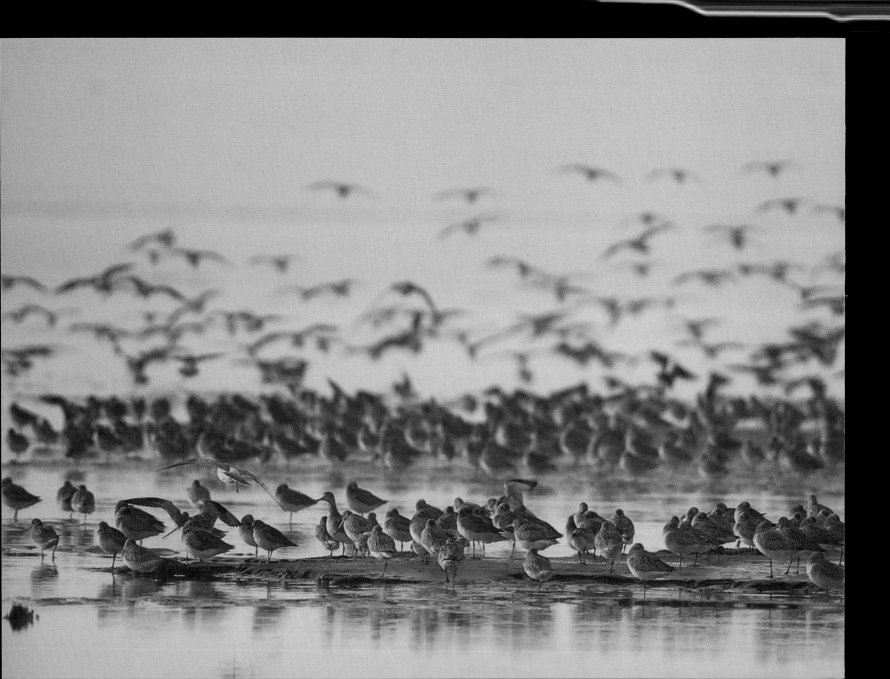

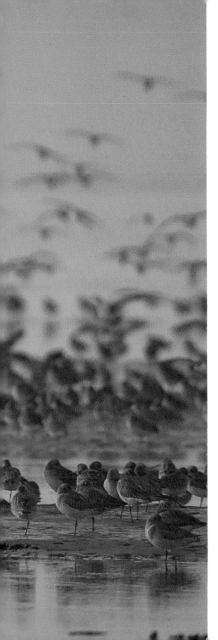

# High-tide on Berwick beach

It is 10 a.m. and, from a hide just above the high-tide mark, I watch the groups of wading birds running to and fro in the sand at the water's margin. As the tide begins to edge closer more and more birds arrive – among them flocks of curlew, dunlin, and godwits – and their piping calls reach a crescendo as they jostle for space on the already crowded beach.

At first I find it difficult to achieve worthwhile compositions from among the seething mass of birds, but I eventually discover that if I pick out a particular bird and keep it in view for as long as possible I can get the desired result. The trick is to wait until the chosen bird pauses to pick up a titbit before taking its photograph.

An hour spent following these frantic goings-on leaves me mentally exhausted and I am relieved when things begin to slow down. Gradually the birds cease feeding and stand, shoulder to shoulder, along the high-water mark. Some balance on one leg, tuck their bills under their wings, and fall asleep; others preen themselves. Eventually they all seem to be waiting, like so many clockwork toys in need of rewinding, for the tide to begin to ebb, signalling the start of the next feeding cycle.

Berwick-upon-Tweed
November

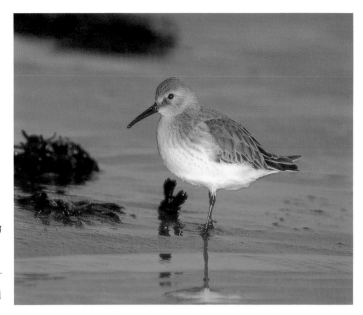

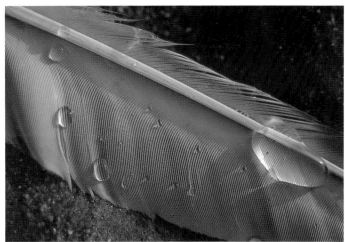

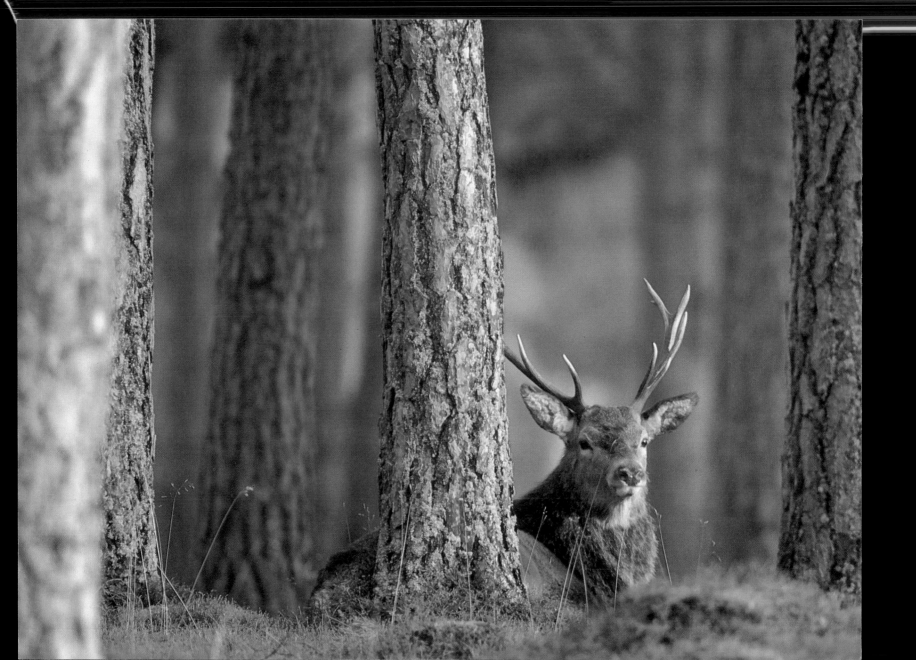

# Red Deer Stags

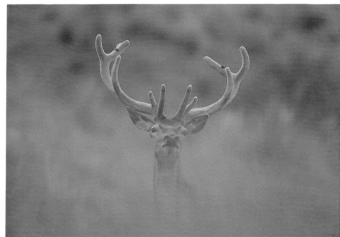

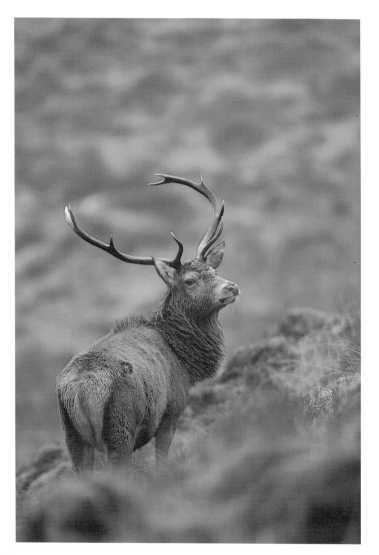

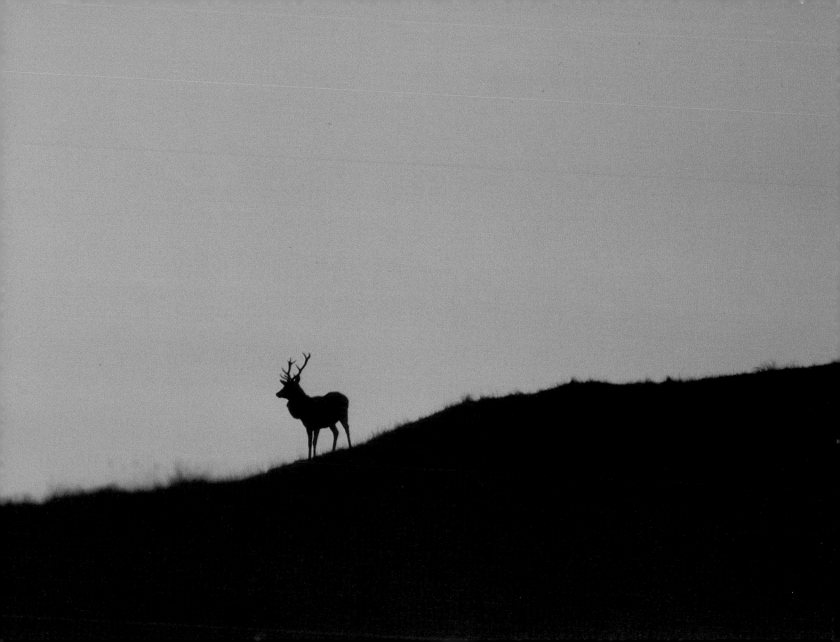

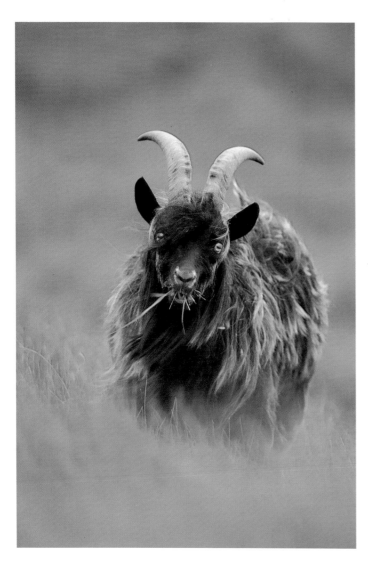

# The wild goats of Rhum

Rhum is a diamond-shaped island which lies south of Skye on Scotland's west coast. It is managed by the Nature Conservancy Council and special permission is needed both to stay on the island and to visit certain areas. It has become a centre for ecological studies and on-going research into a number of particular species, such as red deer and the manx shearwater.

Among Rhum's most notable features are its cliffs – some of them 1,200 feet high – which form the habitat of a feral goat population. Like similar herds elsewhere in the Highlands, these goats were once domesticated but have reverted, over the years, to the wild, long-haired type. At one time they were stalked, which has made them wary and difficult to approach. There are over three hundred goats on the island, distributed over an eight-mile stretch of cliffs, and it was here that I began my four-day assignment to photograph these nimble cliff-dwellers.

### Tuesday
After a long day's travelling I am keen to

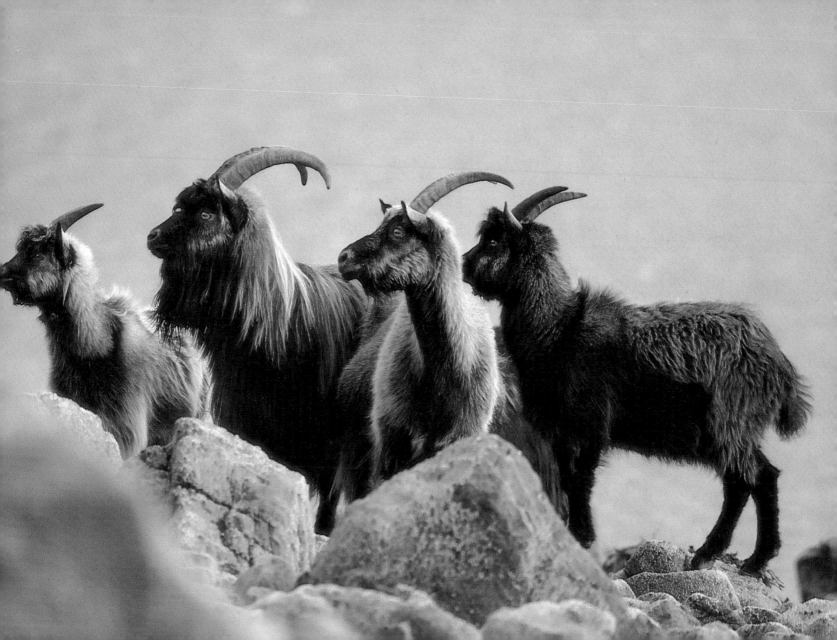

get out and explore my new surroundings. I set out from the bothy and head along the coastline, pausing frequently on the steep hill to rest with my camera equipment. As I walk I keep a watchful eye on the cliffs below but see no sign of any goats. The sun begins to set and I stop on the cliff-top, entranced by the view across the sea to the Outer Hebrides, before picking my way in the gathering darkness back to the bothy.

### Wednesday

I awake early on a clear, sunny day. By seven I am high on the hill taking landscape views when I notice a small herd of goats about fifty yards ahead of me. They are watching me intently and with obvious suspicion. I crouch down and shortly an old female, who I take to be the leader, takes a few steps towards me then pauses. With her head raised and upper lip turned back she sniffs the air, then hisses loudly in alarm. In an instant the whole herd double back and head into a gully. Unable to follow I take several pictures of them from the cliff-top as they make their way sure-footedly down to a patch of loose scree where they finally stop – by now well out of range of the camera.

### Thursday

Continuous rain. I venture out in the morning and spend most of the time sheltering beneath the cliffs near the bay. By mid-afternoon I decide to call it a day and trudge back to the bothy where I light a fire from driftwood to heat water for a bath.

### Friday

The weather is dull but, to my relief, the rain has stopped. Within an hour I find the same herd of goats I had seen earlier and take a wide detour to get round and ahead of them. Fortunately they have not seen me this time. I lie flat out on a large slab of rock, covered with a camouflage net, to await their arrival. Half an hour later the old female comes into range. I take a picture and, at the sound of the shutter, she looks up briefly, still chewing, then resumes her browsing. Soon all seven members of the herd are feeding nearby. As I am reloading the camera the old female becomes curious and walks forward to within ten yards of me. Carefully I close the camera, wind on, and take several head shots of her. She stands her ground. By now the others have noticed that something is going on, and two of the older males come forward to investigate. I keep absolutely still and soon they all wander off and begin feeding again. I take some more pictures then wait until the herd moves out of view before collecting my equipment and beginning the long journey home.

Rhum
August

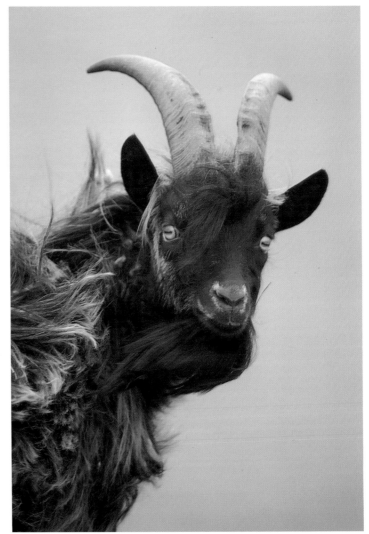

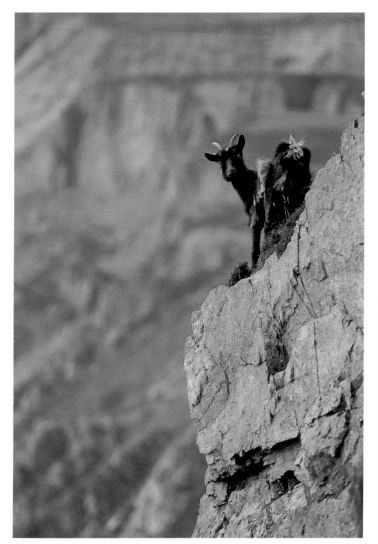

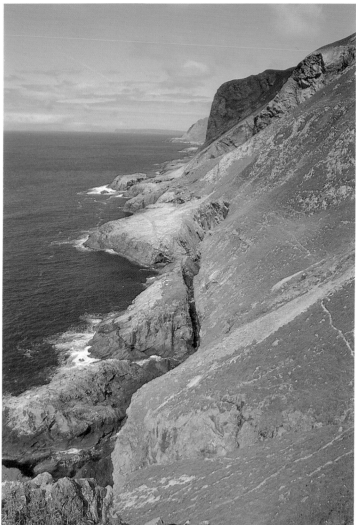

# On a New Year's Day

For several years I had known of a field used by herons as a daytime standing ground and, early in December, I set up a portable hide from which to photograph them. I arrived as dawn was breaking on New Year's Day, having spent the night in a barn to be sure of being in position before the herons arrived.

It was not long before the first birds began to fly in from the river and by ten o'clock there were about thirty herons in the field. Unfortunately all but one landed in the distance – forcing me to take long shots of groups of birds when I had been hoping to get some close-ups. The bird nearest to the hide was obscured by a low hawthorn hedge and at an awkward angle to photograph, but I noticed that it was asleep. I decided to pick up the hide, from the inside, and stalk the heron. As I got nearer I saw that it was a youngster, still in its juvenile plumage. It stood, hunched up, dozing in the cold morning air.

Just as I was attempting to move a little closer it became aware that something was happening and glared in my direction. I froze, trying to remain still while holding the combined weight of the hide and its contents above ground level. Just as I thought my arms would give way the heron lost interest, tucked its head back under its wing and nodded off to sleep again. Gratefully, I lowered the hide and sat down to recover. It had taken me two hours to move forward twenty-five yards, but I now had a clear view of the bird, about thirty feet away, through a gap in the hedge. I began to take pictures and after each click of the shutter the bird looked up suspiciously. Then I discovered that by using the camera's delayed action release I could catch its attention with the whirr of the mechanism before taking the photograph. Eventually even this failed to rouse its interest and it fell asleep again. It remained so until a tractor turned into the field, sending all the herons off in search of a more peaceful place in which to spend New Year's Day.

Near Berwick-upon-Tweed
January

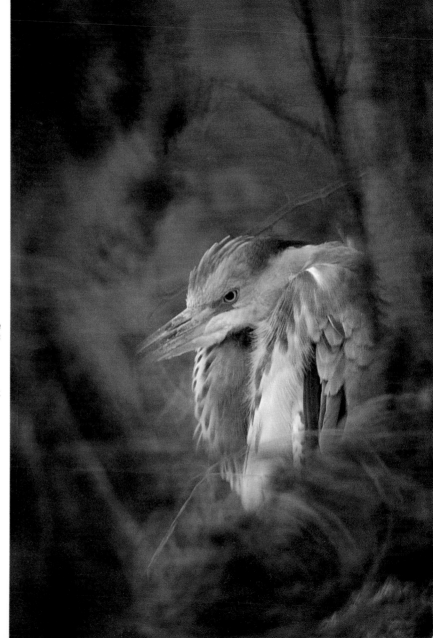

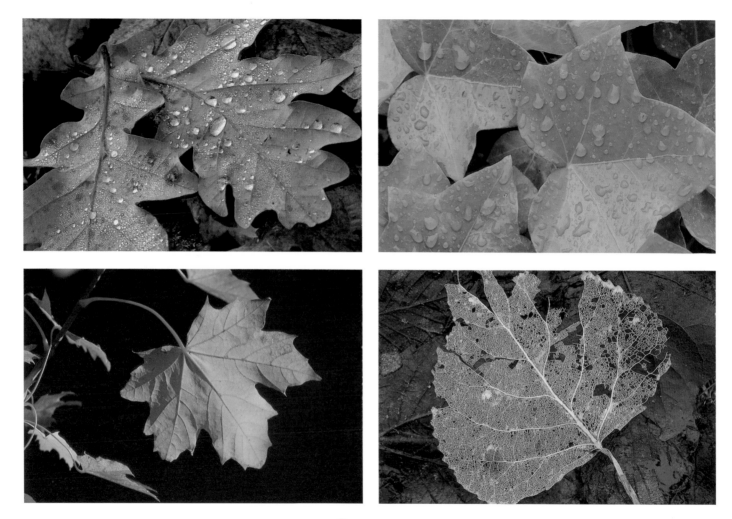

# Leaves

Oak *top left*. Ivy *top right*. Sycamore *above left*. Poplar *above right*.

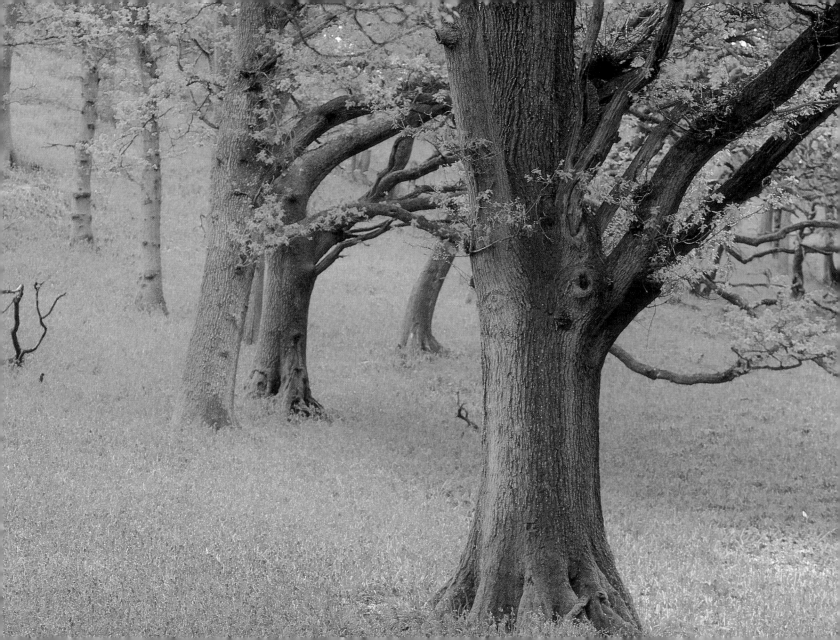

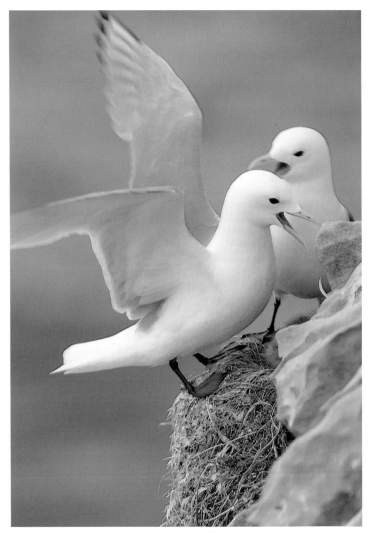

**Kittiwakes**

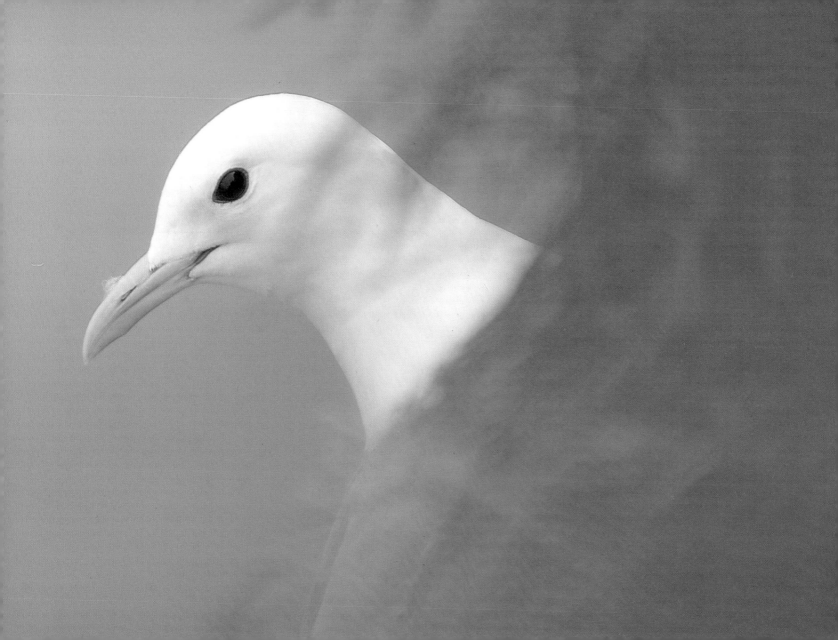

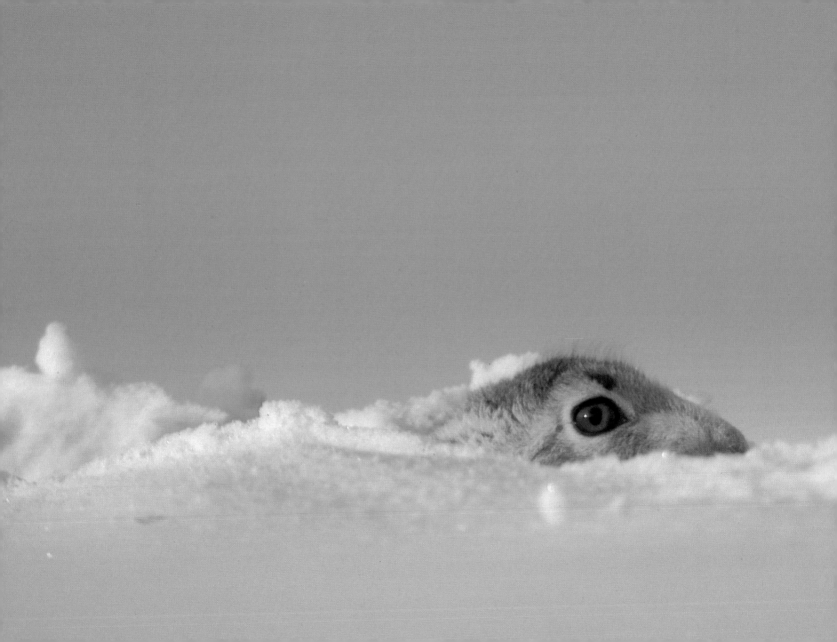

# White hares in winter

On a crisp January morning I headed south from Edinburgh in search of mountain hares in their white winter coats. Within an hour I was high up on the moors, driving along a single track road which had only recently been cleared of snow. A plough had left the snow banked high on each side of the road and I had the impression of driving down a narrow alley. I stopped on the brow of a hill and climbed above the level of the road to take in the spectacular winter view.

Suddenly the peace was shattered as a covey of about forty red grouse exploded from a nearby patch of snow-free heather. They flew rapidly and noisily down the slope before landing about two hundred yards away – no doubt to await my departure and resume their feeding.

The next hill I encountered was steeper and I was forced to reverse back down and fill the boot of the car with large stones from a stream. The added weight got me over the

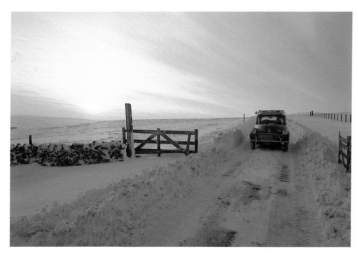

hill and I drove on until I reached a conifer plantation where I stopped for lunch. As I ate, a vividly coloured cock pheasant crept from the edge of the wood to sun itself. I took a few photographs of this splendid bird then set off for higher ground and, with any luck, a sight of some mountain hares.

Arriving at a likely spot I stopped to scan the slopes with my binoculars. There were hare tracks all around and, in the lengthening shadows cast by the afternoon sun, I spotted a pile of freshly disturbed snow. The tips of a pair of ears protruded from a hollow nearby. I managed to crawl to within ten yards of the hare and took three photographs of the pair of eyes that were staring back at me before the animal bolted for cover.

As the day wore on the hares became increasingly active. A little later, using the car as a hide, I got a second series of pictures of a hare at close range. Soon, however, the light began to dwindle and the temperature dropped sharply. Ice began to form on the inside of the car windows and a freezing fog descended. I stopped to photograph a group of trees in the delicate, pastel-pink of dusk, then headed for home. As I drove, hares bounded back and forth across the road in front of me, their ghostly white forms lit for a second in the headlights before disappearing into the darkness.

Lammermuir Hills
January

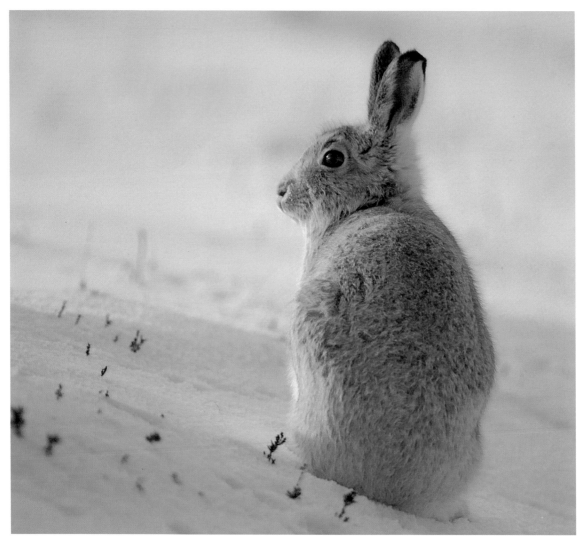

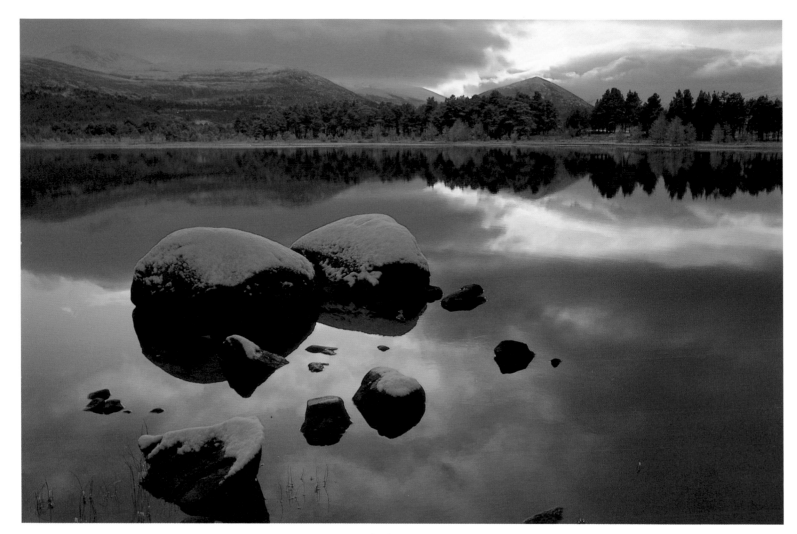

Loch Morlich

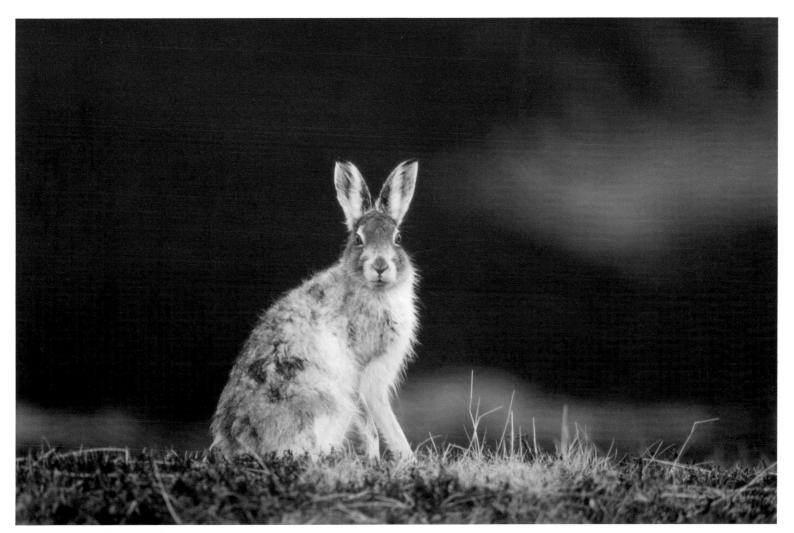

**Mountain Hare**

# Index of species